SAMUEL PALMER

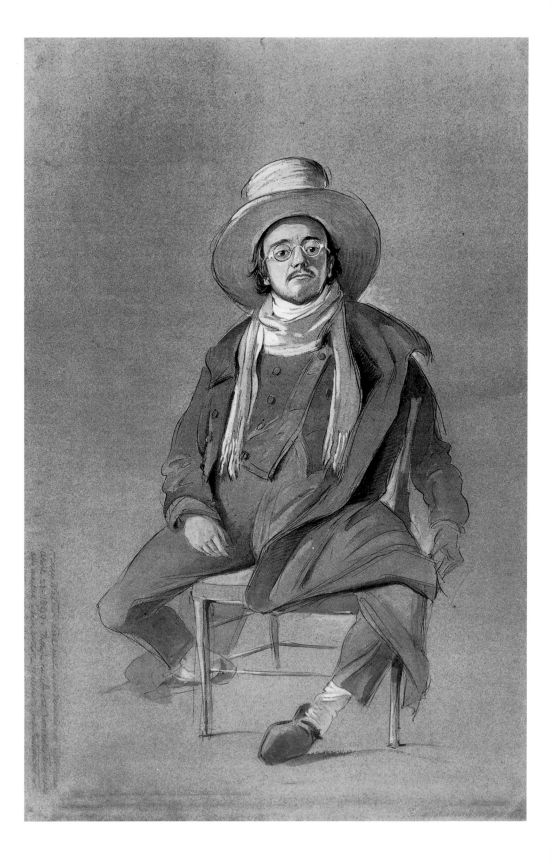

SAMUEL PALMER

Timothy Wilcox

British Artists

Tate Publishing

Acknowledgements

I am grateful to Nicholas Robinson of the Fitzwilliam Museum, Cambridge, for special access to the Linnell Papers, also to Simon Fenwick, Giulia Bartrum, Mark Pomeroy, and Briony Llewellyn. Colin Harrison has been a generous and wise counsellor throughout. Thanks are also due to the Kent Studies Centre, Maidstone, Sevenoaks Library and Maidstone Library.

Chiefly, I would like to thank Richard Humphreys for accepting my proposal; Christiana Payne for encouraging remarks on the first draft; and Judith Severne and Nicola Bion for seeing the book through production.

General Editor: Richard Humphreys, Senior Curator, Tate Britain

First published 2005 by order of the Tate Trustees by Tate Publishing, a division of Tate Enterprises Ltd, Millbank, London SW1P 4RG www.tate.org.uk/publishing

The moral rights of the author have been asserted

British Library Cataloguing in Publication Data
A catalogue record for this book is available from the British Library

ISBN 1 855437 563 6

Distributed in North America by Harry N. Abrams, Inc., New York
Library of Congress Control Number: 2004 111 328

Concept design James Shurmer
Book design Caroline Johnston
Printed in Hong Kong by South Sea International Press Ltd

Front cover: *In a Shoreham Garden c.*1829 (fig.27, detail)
Back cover: *Self-Portrait c.*1826 (fig.12)
Frontispiece: Henry Walter, *Portrait of Samuel Palmer*
Watercolour and bodycolour with pen and ink on grey paper
54.2 × 36.6 (21⅜ × 14⅜)
The British Museum, London

Measurements of artworks are given in centimetres, height before width, followed by inches in brackets

CONTENTS

INTRODUCTION
THE VISIONS OF THE SOUL

The paintings and drawings Samuel Palmer made as a young man are often described as 'visions'. It is a word he liked to use himself; one which evokes an idea of images that have been received from another world, images that are pure, complete, and perhaps prophetic. These visions carry a message, a burden of responsibility that it is then the task of the recipient to communicate. As an artist, Palmer saw his role as the depiction of a better world than that in which he lived. He sustained this resolute strain of idealism, which was expressed during the course of his life in a variety of forms: at first through rural England, then briefly through the peasant life of Italy, and finally through a personal reworking of classical culture. So his artistic 'visions' were hardly ever arrived at through any kind of instantaneous revelation. Most often, they are a complex amalgam of visual and verbal sources, drawing on historic and contemporary art, underpinned by his saturation from an early age in the Bible, Bunyan, Milton, Virgil and a range of more modern poetry and prose. From this rich diet of reading Palmer gained a deep religious faith, coupled with a strong social conscience. However much his paintings look like dreams or private fantasies, he intended them as active contributions to modern debates. When these heartfelt but highly personal statements were spurned by the world at large, he may have chosen to present his ideas in different stylistic guises and different visual media, but he never wavered in his dedication to his essential beliefs. His own vision remained intact to the end.

During his lifetime, very little of Palmer's work was understood or appreciated. His son made an attempt to redress this with a volume of *Life and Letters* published in 1891, a decade after Palmer's death, but this book is tainted with a strand of bitterness and resentment which reveals far more of the author's character than that of the subject himself. Palmer was remembered chiefly as the most important artist to have drawn inspiration from William Blake. This was a dubious distinction, and it was partly with the scholarly re-evaluation of Blake's painting and writing after 1900 that serious interest in Palmer was reawakened. An exhibition of Palmer's work at the Victoria and Albert Museum in the autumn of 1926 had an enormous impact on the public and on critics, and most significantly of all on a generation of British artists who have become known as 'Neo-romantics'. Figures as diverse as Paul Nash, John Piper and Graham Sutherland all found an important example in Palmer, even if what each discovered in him had more to do with their own needs and desires than with any deep appreciation of Palmer himself. It was precisely Palmer's supposed lack of contact with the society of his own day that interested them, the idea of an artist wholly surrendered to his own powerful

imagination. The more Palmer's work resembled observed nature, or the style of other artists, past or present, the less valid it was considered. With appreciation of Victorian art approaching its lowest ebb, it seemed easy to construct Palmer as a figure whose innate genius had been crushed by the tide of nineteenth-century materialism. The idiosyncratic media Palmer employed for some of his best-loved work, especially the early ink drawings, glistening with gum (figs.5, 6, 8), or the dense late etchings (fig.61), reinforced his perceived otherworldliness.

Having had little to do with the nineteenth century, Palmer could all the more readily adapt to the twentieth. Modern art, in the prevailing Bloomsbury aesthetic of Roger Fry or Clive Bell, rested on 'the intuitive and supposedly disinterested experience of an emotional or spiritual value'.[1] Palmer, particularly in his work of the 1820s, fully revealed for the first time in 1926, seemed entirely suited to this kind of re-interpretation. In the present era of postmodernism, fascination in Palmer is, if anything, increased. Attention to ways of subverting modernity has led to renewed interest in the pastoral, a form Palmer used and studied in depth. He could be placed alongside his near contemporary, the French painter Camille Corot, whose misty idylls, in the words of art-historian T.J. Clarke, 'grapple head on ... with the disenchantment of the world'.[2] Except that Palmer was not truly disenchanted, nor, indeed, was his ideal viewer a disinterested one. The task of this short study is to rediscover the historical Palmer, to demystify an artist almost as well known for what others thought of him as for what he thought himself.

As an artist, Palmer was almost entirely self-taught. This contributes to the individuality in his work that is so much admired today. But throughout his career his lack of basic training was to prove a handicap as well as a source of strength. He could be boldly experimental – witness the bodycolour in some of the Shoreham drawings (figs.25–6), or the intricacy of the late etchings (figs.57 and 61), which reverberated almost endlessly in the work of other artists through the 1930s and 1940s – while showing a wilful disregard for conventional standards of finish. In their technical aspects alone, Palmer's works reveal his uncompromising spirit, which he is unable to disguise, even when he is consciously attempting to conform, as he is in many of the watercolours painted for exhibition from the 1840s onwards.

The span of Samuel Palmer's life, from his birth in 1805 to his death in 1881, encompassed the greater part of the nineteenth century. Britain was firmly established as the world's greatest military and economic power, yet with this came the fiercest intellectual and religious controversies the country had seen since the Reformation. Palmer was a product, and in some ways a victim, of these circumstances. His father, another Samuel, came from a well-established family of felt-makers in the City of London, numbering several clergymen among their antecedents. His mother, Martha, was the daughter of a banker and stockbroker; her dowry provided the couple with a modest independence. The legacy of £3,000 that came to her son on the death of her father, William Giles, in 1826 enabled Palmer to move to Shoreham and acquire property the income from which would help sustain him when his painting could not.

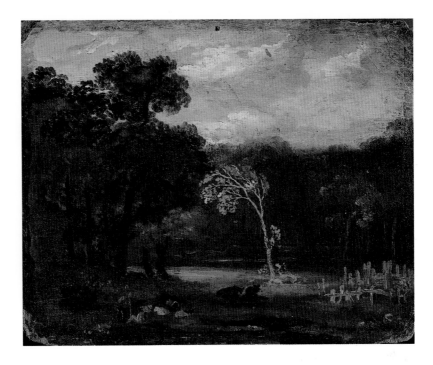

Palmer's parents were both staunch Baptists and Samuel, with his younger brother William, was brought up in their faith. During his boyhood, war with France added to the pressures exerted on dissenters, and it was widely considered unpatriotic not to adhere to the Church of England. In 1823, when he was eighteen, Palmer forsook his parents' faith to join the established church. This is one of several instances in his life when he allied himself with the respectability and traditions of the establishment, while at heart, in his habits of thought and manner of life, he remained in the wider sense a nonconformist. When in 1837 he married the daughter of his artistic mentor John Linnell, a Baptist convert, Palmer destabilised a core area of his life where he had expected certainty and security. During the 1830s and 1840s, the Church of England was threatened not by free-thinking Protestants so much as by Catholicism. Though Palmer ostensibly resisted the arguments of the Oxford Movement, which wanted to bring the English church closer to Rome, in 1842 he christened his eldest son Thomas More, after the sixteenth-century Catholic martyr. Palmer's cousin John Giles remained his closest friend throughout his life; Giles entertained a long flirtation with Anglo-Catholicism, and one of his nephews became a Catholic bishop.[3] It is perhaps no surprise that one of the very few overtly religious subjects Palmer tackled in later life concerned the physical and spiritual battle of Jacob wrestling with the angel (present whereabouts unknown). The ideal world he depicts in many other paintings is never entirely beyond the scope of religion. Present through various motifs embedded in the landscape, rather than brought to the foreground as the primary subject, he could never forsake some reference to his

beliefs, continually seeking through his work to resolve tensions which were insoluble in real life.

Palmer was educated largely at home. His father, following his marriage, had set up as a bookseller in London and through him Samuel gained an early familiarity with all types of literature. He learnt some Latin, and studied classical authors alongside Bunyan's *Pilgrim's Progress* and other Puritan devotional writings. It was his nurse, Mary Ward, who fostered in him his greatest love, for the poetry of Milton. The pocket edition of Milton that she gave him remained one of his most treasured possessions. The bond between them undoubtedly strengthened in 1818, when Palmer's mother died. At this point his brief period of formal schooling was abandoned and a drawing tutor named William Wates, a painter of landscape sketches in the picturesque tradition, was found for him. Wates must have given his precocious pupil some instruction in oil painting, as Palmer exhibited two oils at the British Institution in 1819, aged only fourteen. When one of them sold, it must have appeared as if his future as a professional landscapist was secure.

A small study in oils (fig.1) gives some indication of Palmer's early achievements. It is an exercise in light and tone, avoiding any problems of perspective, yet with the sapling spot-lit in the centre bringing an unexpected note of drama. This is the first indication of an intense feeling for the character of trees that will form an unbroken strand throughout his entire output. A sketchbook from the same year, 1819, shows Palmer still working through the elementary lessons of the popular drawing tutors, such as David Cox's *Treatise on Landscape Painting and Effect*, while also getting to grips with the more robust diet of J.M.W. Turner's *Liber Studiorum* (British Museum). It is Turner, with his turbulent skies and inventive spatial construction, who lies behind the watercolour sketch *At Hailsham* (fig.2). Painted in Sussex in 1821, this watercolour was the basis of a substantial oil painting exhibited early in 1822 (untraced; Lister 1988, no.33).

Still only seventeen, Palmer was undoubtedly talented, but lacking direction. At this point he was introduced to John Linnell. The introduction was effected by Francis Oliver Finch, a watercolour painter who, like Linnell, had had the benefit of a systematic training by John Varley. Thirteen years older than Palmer, Linnell had himself been a child prodigy when he entered the Royal Academy Schools in 1805 at the age of thirteen. Following his conversion as a Baptist in 1812, Linnell became deeply distrustful of any form of human authority. Rather than recommend Palmer follow in his footsteps at the Academy, Linnell directed his studies independently, sending him to draw from classical sculpture in the British Museum, and suggesting prints he should copy. They visited Dulwich Picture Gallery together, but when Palmer recorded his approval in his notebook for paintings by the Dutch masters Ruisdael, Potter and Cuyp, he now found in them much more than the naturalism that inspired his study in Sion Park. 'How intense, how pure, how profound, how wonderful', he wrote.[4] Although he had been immersing himself in the prints of Dürer and following Linnell's injunction to 'look for van Leydenish qualities in real landscape', Palmer's response to the Dutch shows him penetrating beyond style, surface and structure to discover the soul of the landscape.

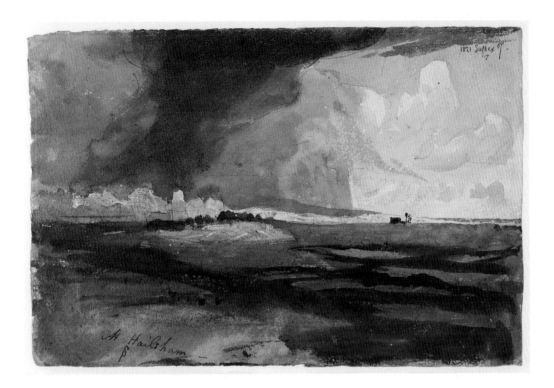

2 *At Hailsham,
Sussex: A Storm
Approaching* 1820
Watercolour over
pencil on paper
21.1 × 31.8
(8¼ × 12½)
Yale Center for
British Art, Paul
Mellon Collection

Palmer's sheer enthusiasm, his ability to surrender himself to a work of art and be overwhelmed by it, emerges most strongly in the next encounter of his early years, his meeting with William Blake. His reaction to the little wood engraving Blake had recently completed for a school edition of Virgil's *Eclogues* appears out of all proportion to the scale or quality of the works themselves; this, though, was the level of response Palmer would expect to arouse from his own designs (fig. 3). To him, Blake's wood engravings 'are visions of little dells, and nooks, and corners of Paradise; models of the exquisitest pitch of intense poetry. I thought of their light and shade, and looking upon them I found no word to describe it. Intense depth, solemnity, and vivid

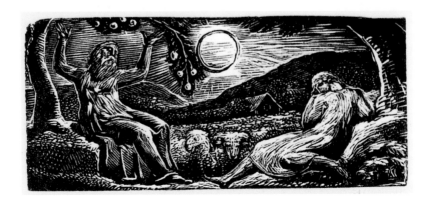

3 William Blake,
*Thenot and Colinet
Converse* 1821
Wood engraving on
paper
3.3 × 7.5 (1¼ × 3)
Tate

brilliancy only coldly and partially describe them. There is in all such a mystic and dreamy glimmer as penetrates and kindles the inmost soul, and gives complete and unreserved delight, unlike the gaudy daylight of this world.'⁵

Palmer was introduced to Blake by Linnell in the autumn of 1824, and the comments on the Virgil wood engravings seem to have been written a few months later, in a notebook since destroyed. In the interim, Palmer had learnt to concentrate on extracting the essence of the landscape, not fearing to be guided by his inner eye, and by the emotional content of the image, rather than the technical and more purely visual constraints he had addressed with Linnell. The impact can be seen most clearly in comparing the sketchbook Palmer had begun to use in 1824 before meeting Blake, with a group of varnished ink drawings, some of which are dated 1825 (figs.4 and 5). The first leaves of the sketchbook are full of grandiose compositions of village festivals, celebrating rural society as a cohesive, harmonious unit. Palmer had evidently already been looking at Blake's designs for the Book of Job, commissioned by Linnell in 1822, but he had also imbibed the expansive, world-encompassing landscapes of Pieter Breughel. An echo of Brueghel survives in *The Valley Thick with Corn*, where the background is divided between a flat receding portion on one side and a precipitous mountain on the other, as in the Flemish master's engraving *The Rest on the Flight into Egypt* of around 1555–6 (figs.6 and 7). The other drawings are much more intimate, with cramped, enclosed spaces dimly lit by the setting sun, moon and stars. Brueghel's mastery of space is forgotten in favour of a more primitive, almost medieval atmosphere, composed of tightly interlocking shapes patterned with different types of vegetation. Such self-conscious archaism had been an element of the pastoral in

4 *Leaf from 1824 sketchbook*
Pen and brown ink on paper
11.6 × 18.9
(4⅝ × 7½)
The British Museum, London

literature and in art since the Renaissance. From the end of the eighteenth century the Gothic was espoused by artists opposed to the hegemony of Greek, or neoclassical, art, with Blake among its most vociferous proponents. For Palmer, Gothic was associated less with a denial of academic authority, though it certainly was that, as with a lost era of authentic spirituality. When he saw Milan Cathedral in 1837, he described it as 'a wonder of holy, Gothic, inspired art[;] its dim religious light gilds the very recesses of the soul'.[6]

The mystic glimmer that so captivated Palmer in Blake's pastorals is most perfectly realised in *Late Twilight* (fig.8). In one corner, a shepherd sleeps sprawled across his flock, while close by a rabbit grazes. A figure beyond the central gate stands on the axis of the near-symmetrical composition; his shoulders stroked by moonlight, he appears lost in contemplation of the peace and plenty that surround him. The character who dominates the foreground of *The Valley Thick with Corn* is rather more problematic. Turning his back on the lush autumnal landscape, he is portrayed reading a book. He wears the plain doublet and starched shirt cuffs of a seventeenth-century Puritan, but cannot be taken as a representation of either of Palmer's literary heroes, Bunyan or Milton, despite some similarities with the often-reproduced frontispiece

6 *The Valley Thick
with Corn* 1825
Brown ink with gum
on paper, varnished
18.2 × 27.5
(7⅛ × 10⅞)
Ashmolean
Museum, Oxford

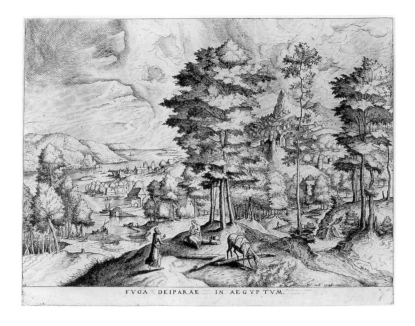

FVGA DEIPARAE IN AEGYPTVM.

7 Johannes van
Doetechum the Elder
and Lucas van
Doetechum, after
Pieter Brueghel the
Elder
*'Fuga Deiparae in
Aegyptum' (The Flight
into Egypt)* 1555–6
Etching with
engraving
31.4 × 41.6
(12⅜ × 16⅜)
National Gallery of
Art, Washington DC,
Rosenwald
Collection

to *The Pilgrim's Progress* (fig.9). The pose of the semi-recumbent figure seems to derive from Jacobean tomb sculpture (such as the effigy of Lord Rich, fig.10), perhaps creating a sense that the landscape behind him is a prefiguration of the Paradise to which the devout reader aspires.

Palmer has inscribed his own name boldly, as a signature, beneath the man's left leg, and in one sense the man is an image of the artist himself. Much later, in two separate accounts Palmer gave of his life in Shoreham – 'that genuine village' – he recalled how he had 'mused away some of my best years … contracting among good books a fastidious and unpopular taste'.[7] Well might he imagine himself as a reader in an earlier, more spiritual age, poised, as the echo of the effigy suggests, between this world and the next.

Meditating on the Bible was a key element of personal devotion among the Puritans, and something Palmer, with his nonconformist background, must have practised since childhood. But in this, as in several others among the 1825 drawings, the central place of the village church, with its prominent tower or spire, reflects Palmer's current belief in the Church of England as a potent presence, not only spiritual and religious, but also physical and social.

The interpolated reader is also a reminder of one of the essential characteristics of the pastoral in all ages; it is viewed from the outside, and designed to reflect back on the sophisticated – and often more corrupt – manners of town or court. 'Rural poetry is the pleasure ground of those who live in cities',

9 Frontispiece to
John Bunyan's *The
Pilgrim's Progress*
1679
The British Library,
London

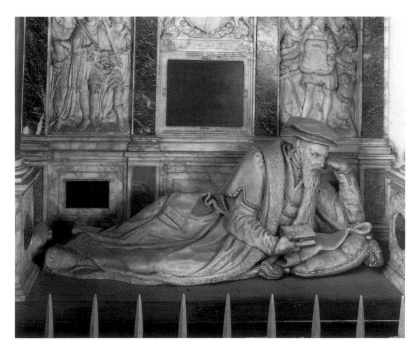

10 Attributed to
Epiphanious
Evesham
*Monument to Lord
Rich c.*1620
Marble
Holy Cross Felsted,
Essex

as Palmer himself put it in the Introduction to his own translation of Virgil's *Eclogues*.[8] The framing device, distancing the viewer, occurs in several of the more complex drawings at the beginning of the 1824 sketchbook (fig.11). One sketch seems directly to anticipate the 1825 drawing: the whole foreground is taken up by a musing female figure, her head propped on her hand. The book in her other hand is closed, but it is clearly inscribed 'Holy Bible' on the spine, and there is an extract from one of the Psalms written on the side: 'The earth is full of Thy riches'. For Palmer, full of youthful fervour, the image is less an illustration of the text than the realisation of a promise.

The Valley Thick with Corn stands, nonetheless, as a reminder of how bookish an artist Palmer was, even in the midst of his purest visions. Not for him the sheer sensuality of Keats; Palmer's landscape was most often mediated through literature, and his own awareness of this is displayed in the images themselves. This self-knowledge did not however prevent him from wanting to turn his rural dream into reality, and to accomplish this, in 1826 he moved to Shoreham in Kent.

11 *Leaf from 1824 sketchbook*
Pen and brown ink on paper
11.6 × 18.9
(4⅝ × 7½)
Victoria and Albert Museum, London

I

EARLY MORNING:
POETRY AND SENTIMENT

Samuel Palmer's meeting with William Blake in October 1824 had an enormous impact on his art. Blake's complete commitment to the power of the imagination triggered a response in Palmer and released a tide of paintings and drawings that were distinctive and highly personal. It says much for Palmer's strength of purpose that he was not overwhelmed by Blake, nor substantially diverted from pursuing ideas he already possessed in embryo. Palmer must have been told that Blake had received a visitation from the spirit of Milton many years before. He also wrote with approval of 'such supernatural works as Mr Linnell's picture by Lucas van Leyden'.[1] There is no evidence, though, that Palmer followed them into the realm of spirits. On the contrary, he remained remarkably grounded within the orthodoxies of his Christian faith.

Palmer was not alone in his enthusiasm for Blake. Around him gathered a small group of like-minded friends. At the core were two other artists, Edward Calvert and George Richmond, with another half a dozen associates, including the watercolourist Francis Oliver Finch, the engraver Welby Sherman and Palmer's stockbroker cousin John Giles. They called themselves 'The Ancients' to indicate their rejection of modern values in art and in society, a move that anticipates the founding of the Pre-Raphaelite brotherhood just over twenty years later. Blake's tiny apartment in Fountain Court, off the Strand, was dubbed 'The House of the Interpreter', with Blake himself as the living embodiment of the character in *The Pilgrim's Progress* who explained to Christian the spiritual import of a series of enigmatic tableaux. As a young man, Blake had criticised Bunyan for being too simplistic in the parallels he drew between physical experience and the spiritual life, but in old age he appears to have softened, and began a series of paintings based on Bunyan's classic text, partly as a response to The Ancients' interest in it.

The parables expounded by the Interpreter had two aims: firstly to equip Christian and encourage him on his journey, and secondly to help him reach his ultimate goal, the Heavenly City, or the perfect life of Paradise. In the same way, The Ancients were far from simply backward-looking. In the spirit of Blake's pronouncement, 'The Nature of my work is Visionary or Imaginative[;] it is an endeavour to restore what the Ancients called the Golden Age' (a reference, incidentally, to the fourth of Virgil's *Eclogues*), Palmer and his fellows saw their art as ushering in a new reality.[2] However temporary and provisional, its only value lay in its ability to reflect the ultimate truth of Heaven.

One recent writer has pointed out the tensions inherent in Bunyan's fable,

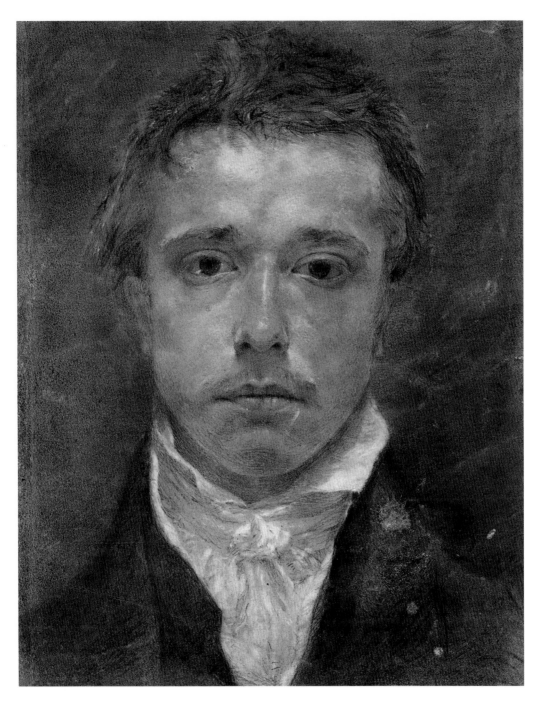

12 *Self-Portrait c.*1824–5
Black chalk heightened with white on buff paper
29.1 × 22.9 (11½ × 9)
Ashmolean Museum, Oxford

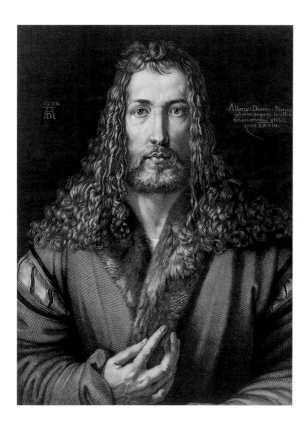

13 François Forster
after Albrecht Dürer
Self-Portrait 1822
Engraving
24.8 × 19 (9¾ × 7½)
The British Museum,
London

where bliss is always anticipated, but never attained.[3] Disquiet of a similar sort seems to manifest itself in the self-portrait Palmer drew in 1824–5, around the time of his meeting with Blake and the formation of The Ancients (fig.12). The pose, looking forward, is rarely employed for commissioned likenesses, but had a venerable tradition in self-portraiture, with Dürer's painting of *c*.1500 at its head. Though previously copied and occasionally imitated, this self-portrait only became widely available as an engraving in the 1820s (fig.13). A rare exception to this general rule is a frontal portrait of Blake dating from the first decade of the nineteenth century by an artist as yet unidentified (fig.14).[4] If Palmer knew this work, the intensity of the stare is something he may well have wanted to emulate. In the self-portrait, as well as looking directly out at the viewer, the artist is also staring intently at himself; one might almost say into himself, such is the almost hypnotic fixity of the gaze. According to the science of physiognomy expounded by Johann Caspar Lavater, which was held in great esteem by both Blake and Linnell, the eyes were not considered 'the windows of the soul'; he regarded the mouth as the most expressive feature. In his drawing, Palmer certainly gives it special prominence. Perhaps more likely to be overlooked, but in physiognomy of equal, or even greater, significance, is the forehead. In the 'Visionary Heads' that Blake drew for the artist and astrologer John Varley, the likenesses of ancient heroes appear to embody an understanding of physiognomy in the way their features reflect their characters. 'The man who taught Blake paint-

14 ?After William
Blake
Self-Portrait
*c.*1819–25
Pencil and grey wash
heightened with
white
24.3 × 20.1 (9⅝ × 8)
Private collection

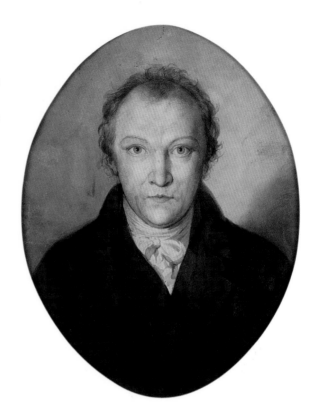

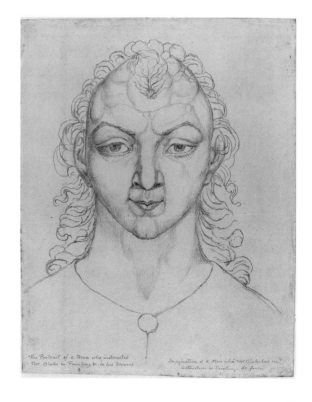

15 Attributed to
John Linnell
*The Man who Taught
Blake Painting in his
Dreams (after William
Blake)* 1819–24
Pencil on paper
26 × 20.6
(10¼ × 8⅛)
Tate

ing in his dreams' cannot be compared with any historical individual (fig.15); he is, however, portrayed full face and has a hugely expanded upper forehead, the very part of the anatomy most associated with the imagination and with philosophical understanding. Palmer's interest in such ideas is most evident in the highlights on the forehead, which appear to fall into upper and lower regions, and also divide to left and right. This fourfold division, 'perceptible by a clear, descending light' is, according to Lavater, one of the 'most indubitable signs of an excellent, perfectly beautiful and significant, intelligent and noble forehead'.[5] In other respects, Palmer's head does not manifest the perfect proportions of Lavater's ideal. He must have been satisfied, though, to portray himself as a thinker first and foremost, in part as a corrective to the studied imitation and mechanical care he had lavished as much on this drawing as on any he ever made.

Under Linnell's tutelage, Palmer had not progressed far in his study of the human figure, which makes the achievement of the *Self-Portrait* all the more remarkable. It is indicative of his continuing inclination towards landscape that, having decided to embark on a series of drawings based on the biblical Book of Ruth, he headed for the countryside rather than the life room.

Palmer had first visited Shoreham, in the Darent Valley just north of Sevenoaks in Kent, in 1824. He may have known of it from his father, as a fam-

16 *Rest on the Flight into Egypt c.*1824–5 Oil and tempera over pen and ink on panel 31 × 39 (12¼ × 15⅜) Ashmolean Museum, Oxford

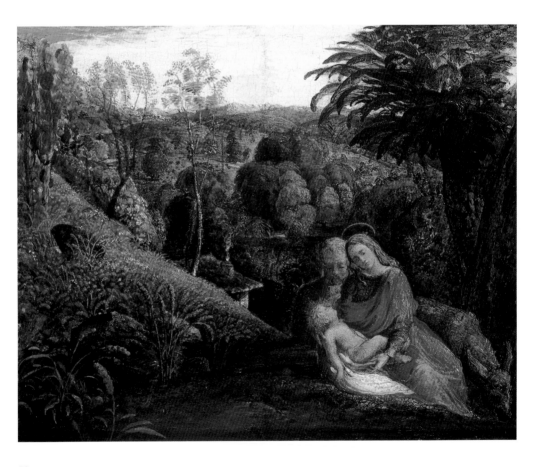

17 George
Richmond
Abel the Shepherd
1825
Tempera on oak
panel
22.9 × 30.5 (9 × 12)
Tate

ily friend had been vicar there at the end of the previous century. Linnell, too, had visited the area, and stayed for a while at Sevenoaks in 1817 while making studies for his earliest paintings of woodcutters. Whether by accident or design, the village was ideally placed to provide Palmer with the greatest possible variety of landscape, cultivated and wild. Shoreham lay on the edge of a band of fertile land renowned not only for its grain crops, but also for its orchards and hops. Just a few miles away to the south, beyond Sevenoaks, lay the Weald, a broad tract of clay, difficult to farm, covered with a mixture of woodland and heath used for grazing livestock in a manner little changed for centuries. According to the account he gave to the critic F.G. Stephens in 1871, Palmer was 'forced into the country by illness'. This was perhaps an early bout of the asthma from which he suffered in later life, though Palmer himself chose to attribute this affliction to the change of climate when he returned from Italy in 1839.[6] At the time, he appeared only too willing to settle for a rural existence, knowing that he was only twenty miles, or a day's walk, from London.

Palmer's first known essay in the prestigious genre of history painting had been the small panel *The Rest on the Flight into Egypt*, painted *c.*1824–5 (fig.16). The richly wooded hills already have a Kentish flavour to them, and may have been based on sketches made during his first visit to Shoreham in 1824.[7] Palmer nods to the supposed setting in Egypt with the introduction of a palm tree to the right, a borrowing from the woodcut of *The Flight into Egypt* by Dürer, a work he knew well enough to be able to draw the trees from memory in his 1824 sketchbook (Victoria and Albert Museum). Work on the painting had 'plunged [him] into despair', and Palmer suffered similar anguish while working on *Naomi before Bethlehem*, which he considered his 'maiden finished

23

figure drawing'. Palmer's son, describing what appears to be another subject from the series, refers to 'two inordinately brawny female figures', presumably Ruth and her mother-in-law Naomi, rendered in the heroic manner of Michelangelo.[8] George Richmond, Palmer's fellow Ancient, was equally under the spell of Michelangelo at this period, but, thanks to his solid training at the Royal Academy Schools, in his *Abel the Shepherd*, exhibited in 1825, he was able to turn the Renaissance master's influence to his own ends (fig.17).

Palmer's two large drawings of subjects from 'Ruth' no longer exist. Perhaps the only record of his ill-fated excursion into the grand manner is *Ruth Returned from Gleaning*. Palmer showed a work with this title at the Royal Academy in 1829, which his son believed was the drawing now in the Victoria and Albert Museum (fig.18). At 294 × 394 mm, it is only slightly narrower than the lost drawings (which measured approximately 295 × 445 mm). Despite its unresolved state, and the anatomical improbability of Ruth herself, this is likely to have been the exhibited picture, though it may have been conceived two or three years earlier than the date it appeared in public.

Apart from the figure drawings, Palmer's initial responses to Shoreham continued in the vein of the ink drawings of the previous year. *A Hilly Scene*, probably from 1826, is painted in the mixed method of tempera with gum Palmer derived from Blake's idea of 'fresco' (fig.19). The flanking trees form

18 *Ruth Returned from Gleaning*
1826–9
Pen and ink, heightened with white bodycolour on paper
29.4 × 39.4
(11⅝ × 15½)
Victoria and Albert Museum, London

19 *A Hilly Scene*
c.1826
Watercolour and gum arabic on paper on mahogany support
20.9 × 13.7
(8⅛ × 5⅜)
Tate

20 *A Shepherd and his Flock under Moon and Stars* c.1827
Pen and ink wash on paper
11.1 × 13 (4⅜ × 5⅛)
Yale Center for British Art, Paul Mellon Collection

into a Gothic arch overhead, as if the very forms of nature cannot help revealing their spiritual character. Linnell, Blake and The Ancients all paid visits to Shoreham during this summer. The nocturnal rambles with his younger friends, singing, or reciting poetry, gave Palmer an even more intense appreciation of the countryside transfigured by moonlight. *A Shepherd and his Flock under Moon and Stars* (fig.20) or *Moonlight Scene with a Winding River* (Yale Center for British Art) are the fullest embodiment of The Ancients' motto, 'Poetry and Sentiment'.

The mood of private reverie present in these drawings was one that Palmer sought to develop further in his next initiative, an attempt at miniature painting on ivory. In November 1827 he wrote to Richmond, asking him to procure tiny slivers '1 inch by 1½ inch up to about 3 inches by two inches'.[9] No more is known of this venture, unless the little woodcut *Harvest under a Crescent Moon* (fig.21) provides a clue to what Palmer wanted to do on such a small scale. It is known that Welby Sherman was cutting a block to a design of Palmer's late in 1826; although *Harvest* is sometimes associated with this endeavour, its composition has more in common with Palmer's paintings of around 1833

21 *Harvest under a Crescent Moon* c.1827
Wood engraving
2.6 × 7.7 (1 × 3)
The British Museum, London

(see fig. 36), and he may have done the engraving himself at that time. The one plate that Sherman did engrave for Palmer, *The Shepherd*, dates from 1828 (fig. 22). It is now virtually the only figure study to survive from the Shoreham years, and shows considerable progress beyond the Ruth drawings of 1826. The desire to make a print of this subject is perhaps a response to the engraving Richmond made while staying in Shoreham in 1827 (fig. 23). The left arm of Palmer's figure is even more elongated than Richmond's, but in other respects Palmer has devised a strikingly original pose to evoke the shepherd's nocturnal meditation – for this is surely what is intended – rather than sleep. The watchful attitude of the dog lends a note of realism which breaks the tranquil spirit of Blake's pastorals on which Richmond still depended so heavily.

Blake died on 12 August 1827. John Linnell had been much involved with Blake's affairs during his last illness, and took care of his widow, finding her new lodgings during the autumn. He had no time to visit Shoreham that summer, but made up for it the following year, with two visits in late August and September. Although he planned to go again to witness the hop-picking, the final excursion did not take place. Linnell had been steering Palmer away from the realms of fantasy, which works such as *A Hilly Scene* still largely inhabit, and encouraging him to make detailed studies of individual features in the landscape, which might then form the basis for saleable pictures. 'Mr Linnell tells me that by making studies of the Shoreham scenery I could get a

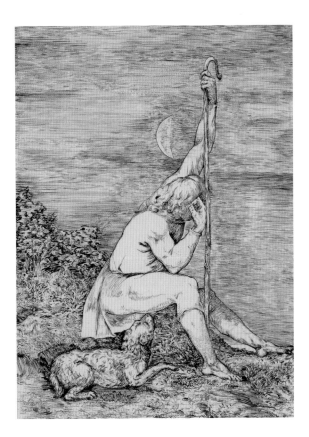

22 Welby Sherman,
after Samuel Palmer
The Shepherd 1828
Engraving
10.8 × 7.9
(4¼ × 3⅛)
The British Museum,
London

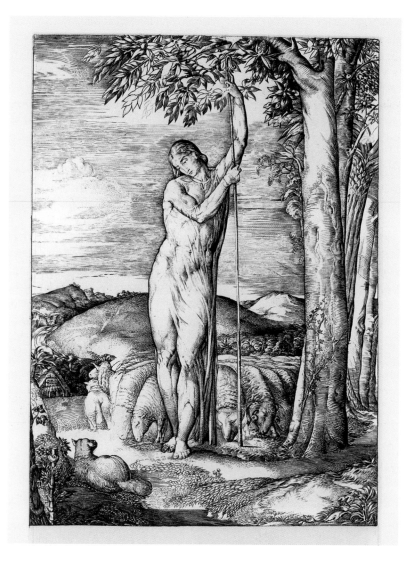

23 George
Richmond
The Shepherd 1827
Line engraving on
paper
17.8 × 11.4 (7 × 4½)
Tate

thousand a year directly', Palmer repeated to Richmond in October 1828. He then went on, revealing a stubborn – and unworldly – streak, 'Tho' I am making studies for Mr Linnell, I will, God help, me never be a naturalist by profession'.[10]

Among the studies Palmer made that year are a number of drawings of the ancient oak trees in Lullingstone Park, whose boundary skirted the northern edge of Shoreham parish (fig.24). When he had been a pupil of John Varley, around 1805, some of Linnell's earliest oil studies were of trees; he showed one to the Academician Joseph Farington in 1806. There is a similar example in the early work of William Henry Hunt, Linnell's fellow pupil and sketching companion at the time (Tate, London).[11] Palmer's trees are nothing like Hunt's careful record of tone and texture, though. Instead, he chose the most grotesquely misshapen specimens, trees which look almost anthropomorphic

in the way their knobbly boughs, produced by pollarding to give cover for deer, stretch sideways while sagging with age. Jacob Strutt was producing the plates for his *Sylva Britannica, or Portraits of Forest Trees* around this time, and exhibiting some examples at the Royal Academy. Palmer may have envisaged his own drawings as having similar potential, beyond that of mere technical exercises. He was unrepentant, though, when he insisted to Linnell in a letter of December 1828 that four words of Milton's poetry, 'Pine and *Monumental* oak', had the power to evoke something more huge than any tree that ever grew in a gentleman's park.[12]

Apart from trees, Palmer's favourite subjects at this time seem to have been the old barns to be found in Shoreham and its surroundings. *A Cow Lodge with a Mossy Roof* (fig.25) is certainly a tour de force of patient observation. To the agriculturalist, though, it might be taken as a prime example of the poor state of repair of many of the farm buildings in Kent. Since one local farmer made this observation in 1805, conditions had generally declined, notwithstanding a brief post-war boom after 1815.[13] The harvest in 1828 was poor; 1829 was worse. Most of Palmer's neighbours in Shoreham would be finding life very tough indeed. Many might have been happy to join the seventy families from the Weald who emigrated in 1827. Not far away, at Petworth in West Sussex, the Earl of Egremont was praised for his magnanimity when he offered to pay the passage to Canada for workers on his estate.

The earliest detailed census of Shoreham, made in 1841, recorded just over 1,000 people living in the village and its outlying hamlets. Of some two hundred households, only ten claimed to have independent means. Another twenty or so were engaged in farming-related trades: there were seven blacksmiths,

24 *Oak Trees, Lullingstone Park* 1828
Pen and brown ink with pencil, watercolour and bodycolour heightened with gum arabic and scratching-out, on grey wove paper 29.5 × 46.8 (11⅝ × 18⅜)
National Gallery of Canada, Ottawa

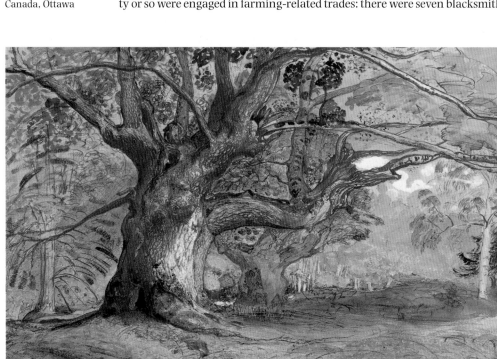

nine carpenters and wheelwrights, a harness maker, shoe-makers and a couple of shops. Industry was represesented by Wilmot's paper mill, which employed half a dozen workers, male and female. All the others worked on the land, as farmers (mostly tenants) or labourers. Throughout this part of Kent, the tally was pretty much the same.

Palmer claimed to 'love our fine British peasantry', but one suspects that Linnell may have been slightly exasperated at his blithe indifference to what was going on around him (when Palmer does express concern that prolonged bad weather is effecting the crops in 1828, he seems equally put out by the disruptions to his own artistic programme).[14] Following his next visit to Shoreham in June 1829, Linnell almost immediately began 'a small picture of a potato field', which in its stark portrayal of field labour is the bleakest rural subject he ever painted, and seems to prefigure Bastien Lepage or Clausen at the end of the century (fig.26).[15] This was a replica of a composition first painted in 1816, and one can only speculate whether this was in any way intended as a 'lesson' for Palmer; the possibility is supported, at least, by some of Palmer's own work, which does appear to be directed primarily towards Linnell.

On 5 September 1828, the day after a joint outing to Lullingstone, Palmer and Linnell visited the garden of Richard Groombridge, one of the more prosperous of Shoreham's farmers. Linnell, in particular, must have been impressed by what he saw there, as his future dealings with Groombridge,

25 *A Cow-Lodge with a Mossy Roof* 1828
Pen and ink with watercolour and bodycolour on paper
26.7 × 37.5
(10½ × 14¾)
Yale Center for British Art, Paul Mellon Collection

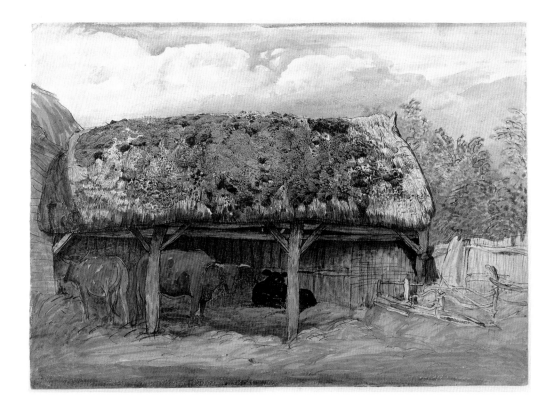

26 John Linnell
*A Potato Field on the
Isle of Wight* 1829
Oil on panel
Measurements
unknown
Present whereabouts
unknown

detailed below, demonstrate. The occasion may also lie behind Palmer's *In a Shoreham Garden*, probably painted the following year, even if the setting seems to be transposed to the walled plot of Palmer's own home at Water House (fig.27). The blossoming tree is an image of springtime, portrayed here with a profusion of blobs of dense white bodycolour; Palmer seems to require the most solid substance with which to incarnate his most extravagant vision. In the distance, a woman strolls by, as if lost in thought, while at the near end of the border she is about to pass, invisible to her, but plainly silhouetted against the yellow background, there is a serpent entwined around a garden stake. It appears as if the Paradise of this modern-day Eve is about to be invaded. Palmer's rendition of the blossom by rhythmic, densely packed circular shapes seems a deliberate echo of one of Blake's scenes of Paradise, *Satan Watching the Caresses of Adam and Eve* (fig.29). One of the versions of this design for Milton's *Paradise Lost* was owned by Linnell, so Palmer needed to have no doubt that the homage would be recognised. At the same time, Palmer was making a statement of his own position, showing his art not as dependent entirely on the imagination but rather as a transfiguration of reality which revealed both the physical and the spiritual in the same image.

The Magic Apple Tree is in many respects the pair to *In a Shoreham Garden*, an autumn scene to complement the blossoms of spring, an image of anticipation finding fulfilment (fig.28). According to Palmer's son, the two paintings were kept together by the artist in a special folder, which was shown only to his closest friends. With a tree as its central subject, the work can be seen as a continuation of the depictions of Lullingstone Park or the Water House garden, though any pretence of realism has been set aside. This is the apotheosis of the apple. Once again, it may have been painted with Linnell as its prime audience.

In November 1828 Linnell took delivery of a number of fruit trees supplied by Groombridge for his garden in Bayswater. Later in the month, he bought three more trees in London, then made a special excursion to acquire a mulberry tree. When he was not painting, gardening was virtually Linnell's only

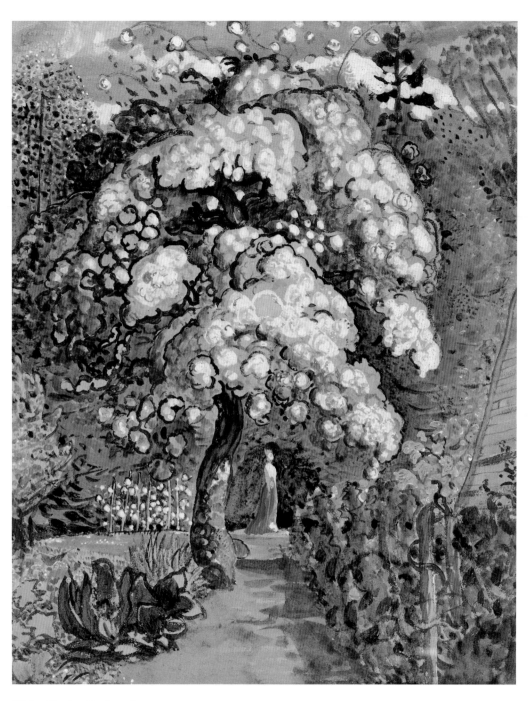

27 *In a Shoreham Garden* c.1829
Watercolour and bodycolour on board
27.9 × 22.2 (11 × 8¾)
Victoria and Albert Museum, London

28 *The Magic Apple Tree c.*1829–30
Indian ink, watercolour and gum arabic on paper
34.9 × 27.5 (13¾ × 10⅞)
Fitzwilliam Museum, Cambridge

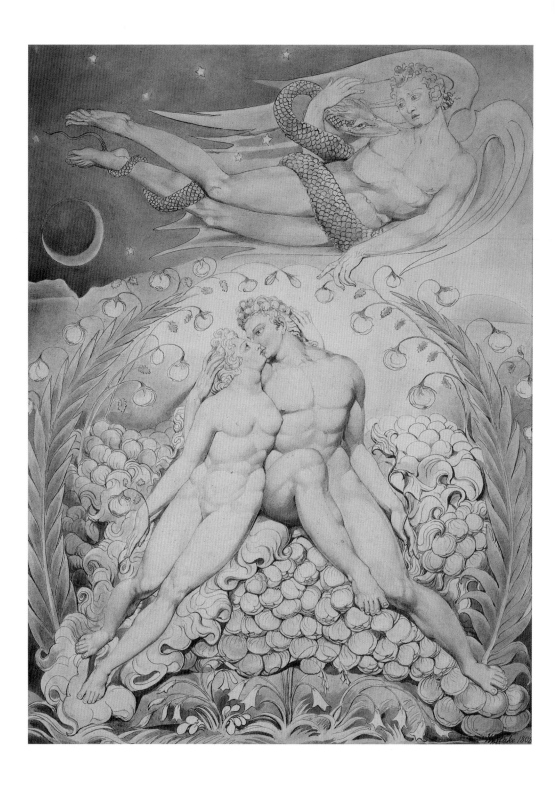

pastime, but one he took seriously enough to register repeatedly in the diaries he kept primarily as a record of his working life. When he moved to his newly built house in Porchester Terrace in 1830, Linnell uprooted many of the plants from his old garden and transplanted them; he does not mention the trees specifically. Twenty years later, Linnell was sufficiently prosperous to have a large house built at Redstone Wood, near Redhill in Surrey. When November arrived, the recommended time, he went personally to select trees for the new garden. They evidently meant a great deal to him.

Palmer's apple tree gains in resonance from its association with the Eden of the Shoreham garden. Here, though, it is as if the Fall never happened. *The Cyder Feast* by Edward Calvert, another of The Ancients, is also a celebration of the apple harvest (fig. 30). Calvert later deleted from the plate the inscription 'By the gift of God in Christ'. The pirouetting couple in the foreground certainly appear to have more to do with the pagan culture in which he later became immersed, than with any type of religious ecstasy. By contrast, Palmer's painting breathes tranquillity and assurance. Its premise is the same as Calvert's caption, but without the dogma.

'The visions of the soul, being perfect, are the only true standard by which nature must be tried', Palmer had written in an early notebook.[16] For many of the Romantics, nature was the ultimate authority. Politically, it became a symbol of freedom from constraint, artistically, an image of boundless renewal. Linnell, on his conversion as a Baptist in 1812, had experienced a surge of enthusiasm in his attention to landscape, seeing every last detail as evidence of God's creativity and generosity. For Palmer, such purely sensory manifesttions of the divine were not in themselves adequate. 'The works of creation will never lift the soul to God', he asserted, in a rather sermonising letter to his wife in 1856, 'until we have been taught that our Lord Jesus Christ is the "Way".' So the church spire, however much it seems to merge into the background, is in every sense central to Palmer's vision. 'Take away [the] churches', he had claimed, 'and you have a frightful kind of Paradise left – a Paradise without a God.'[17]

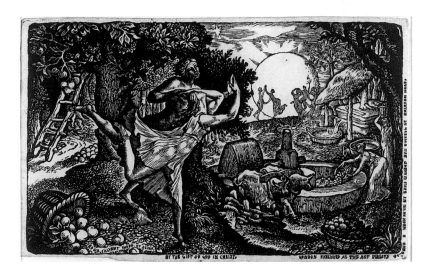

The work which best encapsulates Palmer's idea of the Christian pastoral is *Coming from Evening Church*, dated 1830 (fig.31). It is based on *A Hilly Scene*, one of the first of the Shoreham pictures, where the church resembles that of Otford, the neighbouring village to Shoreham. Although *Coming from Evening Church* bears the inscription 'Shoreham', the Shoreham church had no spire at all, and Palmer is in effect depicting an idealised religious community. The 'flock' are the metaphorical sheep evoked in the New Testament Gospels, filing out of church in a stately procession led by a married couple with children and grandparents, the model nucleus of a settled society. Further back, nearer the church door, stands a robed clergyman.

Even before the paint had dried on Palmer's fictionalised vision of a sanctified rural life, a much harsher reality began to erupt all around him. In July 1830, a wave of riots broke out across southern England, beginning in Kent. In the first week of September, Samuel Love of Filston Farm in Shoreham, and a Mr Jessop in Otford were among the first to suffer from the series of incendiary attacks, rick burnings and the destruction of threshing machines.[18] Shoreham, with its inhabitants mainly dependent on agriculture, had most to lose from continuing low wages and reduced demand for labour – especially through the winter – which increased mechanisation threatened. The July Revolution in Paris undoubtedly added fuel to the expectations of what might be achieved by a popular uprising. Incidents continued throughout the autumn, accompanied by threatening letters signed in the name of 'Captain Swing'. Many property owners gave in to the workers' demands; some destroyed their machinery voluntarily. Shoreham, after the initial outburst, was spared further damage. Palmer seems to have continued working undeterred. Only six months before, in March 1830, he had added the lease of another fine old house in the village to the portfolio of property he already owned, and he was evidently committed to remain.[19]

The value of the houses he owned in Shoreham qualified Palmer as a voter in the parliamentary elections. In 1832, at the December election in which the changes of the Great Reform Act were first implemented, he made a foray into local politics, with a pamphlet entitled 'An Address to the Electors of West Kent'.[20] Quoting from a tract produced in the aftermath of the French Revolution, he accused any reform supporters of Jacobinism, predicting the imminent collapse of British civilisation if his preferred candidate, the independent Tory Sir William Geary, was not elected. 'The ravings of this maniac' was how Palmer's words were introduced in the Reform paper, the *Kentish Gazette*, which printed extracts on 11 December 1832.[21] Three candidates stood for two seats in the constituency. In a close contest, the two Liberals, both of whom had sat in the previous parliament, were elected. Palmer's fears – which he fully indulged with some extreme scare-mongering – may have been shared by a considerable section of the community, however. At the next election, in 1835, Geary topped the poll, but he remained in the seat only for another two years. Nor was Palmer so out of step in Shoreham itself. The individual results for 1832 do not survive, but in 1835, of the thirty-seven eligible voters in the village, seven turned out for Geary and only three for the Liberals.

Palmer's 'Address' focused on the tithe system as one of the chief ties

31 *Coming from Evening Church* 1830
Mixed media on gesso on paper
30.2 × 20
(11⅞ × 7⅞)
Tate

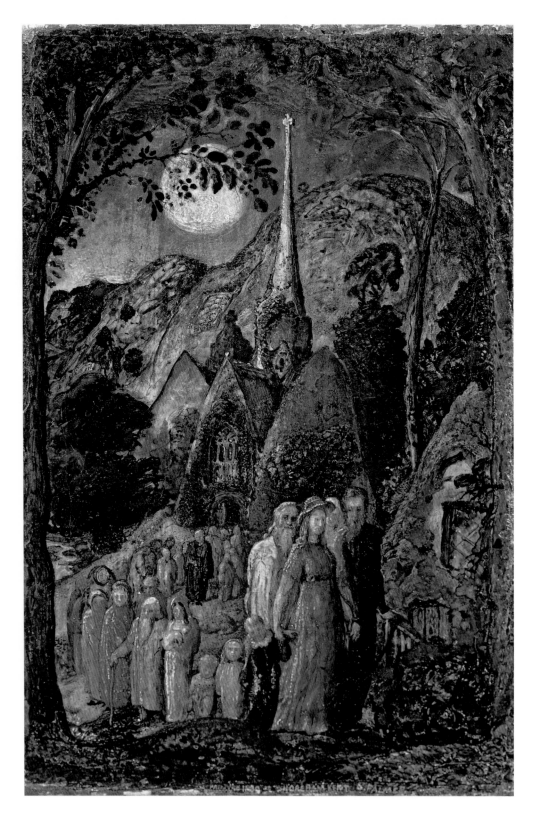

37

binding church and people. Many of his paintings after 1830 feature the harvest, which he evidently viewed as more than the climax of the agricultural year; it was an emblem of the way in which the labour of individuals contributed, from the grass roots, as it were, to sustain the whole fabric of the nation. Both *The Bright Cloud* and *Scene at Underriver* (figs. 32–3) include processions in the foreground, evoking an echo of the classical triumph parade to convey the solemnity of the event. In *The Bright Cloud*, figures carry bins for fruit through fields knee-high with grain, and are followed by a mixed herd of cattle and sheep in an image encapsulating the chief riches the land provides. *Scene at Underriver* is even more expressive of nature's profuse bounty; the figures are relegated to the bottom left-hand corner, and seem to be proceeding into the fields rather than returning from them. What awaits them appears to be an almost impenetrable jungle of vegetation. The hop poles stacked in readiness, with more being carried in by one of the workers, suggest that the greenery, lush as it appears, has several more feet of growing yet to do.

A location for the Underriver hop garden has recently been proposed, and exploration of the locality has revealed that several other so-called 'Shoreham' subjects can be identified in the same area.[22] In contrast to the broad open valley of the Darent at Shoreham, Underriver, beyond Sevenoaks, offered the artist steeply wooded slopes, with houses and barns nestling among the folds of the hills (figs. 34–5). From the ridge overlooking the hamlet, there was

32 *The Bright Cloud*
*c.*1833–4
Oil and tempera on panel
23.3 × 32
(9⅛ × 12⅝)
Manchester City Art Galleries

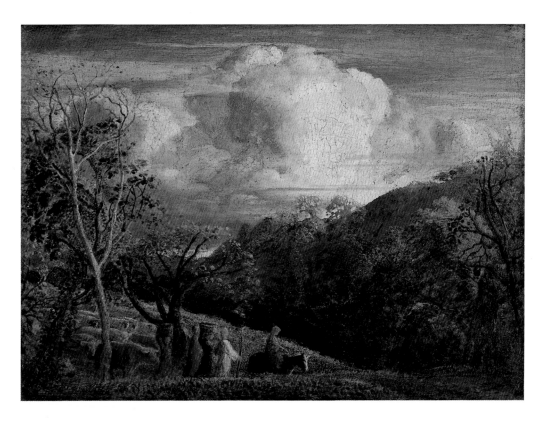

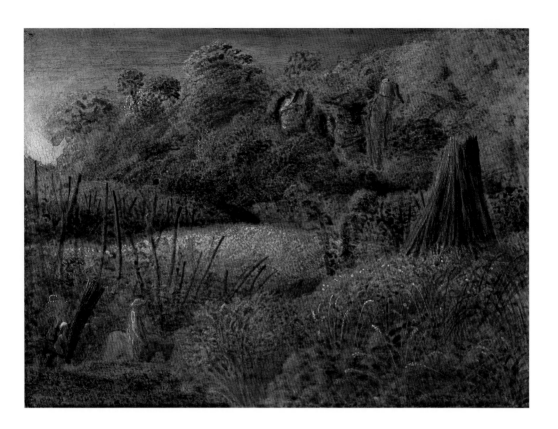

33 *Scene at
Underriver, Kent* or
The Hop Garden
*c.*1833–4
Oil and tempera on
panel
18.8 × 26
(7⅜ × 10¼)
Shizuoka Prefectural
Museum of Art

a spectacular view across the Weald towards the South Downs twenty miles away. This is the setting of the watercolour that has become known as *The Golden Valley*, another scene incorporating a harvest procession (fig.36). Palmer's rendering of the rolling downs as snowy peaks may well owe something to his favourite novelist Ann Radcliffe. Her description in *The Mysteries of Udolpho* of her heroine's homecoming to a house 'bounded by the luxuriant shores of Languedoc and Provence, enriched with wood and gay with vines and sloping pastures' reads like a textual model for Palmer's Earthly Paradise, especially when the view, at twilight, is bounded by 'the majestic Pyrenees; now fading from the eye, beneath the gradual gloom'. Needless to say, Radcliffe did not allow her imagination to be constricted by anything so mundane as a knowledge of geography.[23]

The ox-cart trundling down the slope of *The Golden Valley* stands laden in another work of roughly similar date, *The Gleaning Field* (fig.37). As the sun sets in the far right, a posse of women scatter across the harvest field, stooping to gather what leavings they can find. To see so many of them in so small a space suggests the pressure of need. A statuesque gleaner drawn by James Holmes for a ladies' annual in 1830 gives no such impression of want; neither did the figure of *Ruth Gleaning in the Fields of Boaz* exhibited by Richard Westall in 1835, if we accept the criticism of one writer who found the central character unrealistically affluent in appearance.[24] Gleaning had been

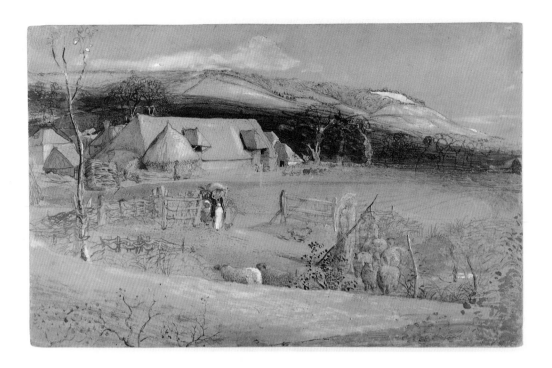

rendered illegal by a court ruling in 1788, but was still widely practised; it has been called 'the last formalised survival of peasant rights in the nineteenth century'.[25]

Apart from the ungainly postures of his figures, Palmer has another strategy to convince the viewer that his is an eye-witness account: he positions in the left foreground a small still-life of a hat, a staff, a cider flagon and a bundle. It is as if a traveller had paused for a moment, and set down his belongings while he observed the scene. Surely that traveller is Palmer himself, who acknowledges through these attributes that he is an outsider, an observer of a world that he is not – perhaps to his regret – truly part of. Of course, these belongings could have been left there by anyone, except that there is plentiful evidence in the 1824 sketchbook and in *The Valley Thick with Corn* of Palmer's preoccupation with framing devices; it is as if he wants his viewers to recognise, as he must also himself, that his is not a universal reality. Palmer knew only too well that his way was not Linnell's or Blake's; it was even further from that of artists who were achieving success in the market place, such as Francis Danby or John Martin. The accoutrements of the unseen viewer demonstrate poignantly – and honestly – that we are being presented with no more, or no less, than a point of view.

One of the barns he drew from a distance at Underriver seems to be the setting for what is surely the grandest of the Shoreham paintings, *The Shearers* (private collection; Lister 1988, no.178). The internal framing device here makes its most explicit appearance, both in the timbers surrounding the group of figures, and the trees which allow a glimpse of rolling hills where

34 *The Valley of Vision* 1828
Ink, wash, bodycolour and pencil on paper
28.3 × 44.5
(11⅛ × 17½)
Yale Center for British Art, Paul Mellon Collection

flocks can be seen grazing. These screens, like flats in the theatre, divide the space very firmly into foreground, middle ground and background. From the evidence of two studies, it appears that Palmer took particular trouble with the still-life group to the right, but for all the convolutions of the entangled struts and staves, it looks completely contrived, and only adds to the staginess of the entire composition.

The painting, perhaps more than any other, shows Palmer at a crossroads. When he came to Shoreham, seven years earlier, he was financially independent, confident of himself and his abilities. He could afford to adopt the primitivism of the early German and Flemish printmakers he so loved, and disdain modern convention, artistic and social. By 1833, when he came to paint *The Shearers*, his modest inheritance was all but spent. Agricultural unrest and political upheaval had dented his youthful optimism. Most disturbing of all, he had achieved virtually no recognition for his endeavours as an artist. Palmer's apparent insouciance did not preclude a burning ambition to cause a revolution of his own, through his art. To do this he needed at the very least to have his work exhibited. If he was going to win over the critics and patrons on whom his future now depended, he needed to impress them, not only with his imaginative powers, but with his technical ability, an area in which he was

35 *The Primitive Cottage c.*1828–9 Pen and ink wash, heightened with white, on paper 22.4 × 30.2 (8⅞ × 11⅞) Victoria and Albert Museum, London

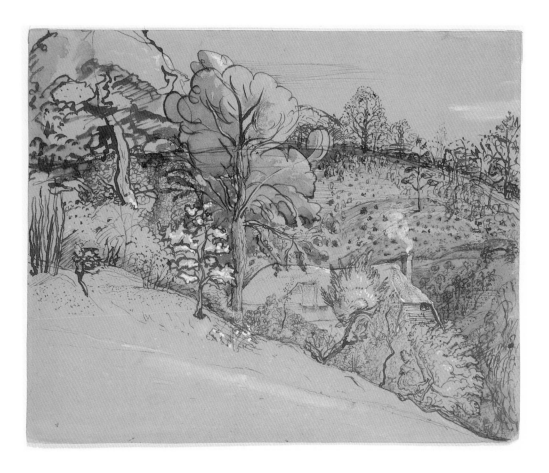

feeling more and more vulnerable and inadequate. *The Shearers* certainly looks intended for a London exhibition; if Palmer did succeed in showing it, perhaps as *A Kentish Scene* at the Royal Academy in 1833, it failed to make any impact whatever.

Two other intimately related factors also increased the pressure on Palmer at this moment: John Linnell, whose advice Palmer so often chose to ignore, was attracting increasing attention for his own landscapes, while Palmer was consistently overlooked. More importantly, Palmer had declared to Linnell, on 6 July 1833, the 'first hint' that he was interested in taking Linnell's daughter Hannah, then just fifteen, as his wife. This was the moment to bid farewell to the Valley of Vision and try to earn a living.

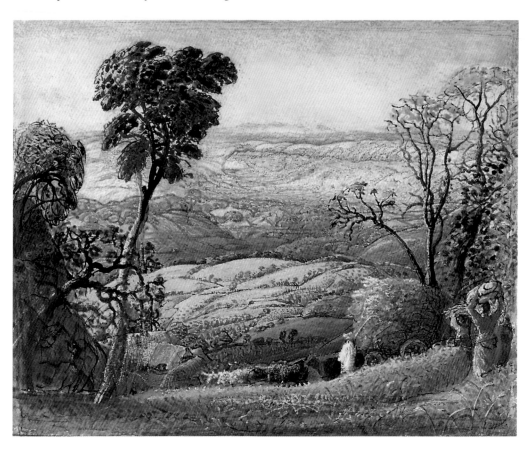

36 *The Golden Valley*
*c.*1833–4
Watercolour, ink,
pen, heightened
bodycolour and gum
arabic on paper
13 × 16.2 (5⅛ × 6⅜)
Private collection

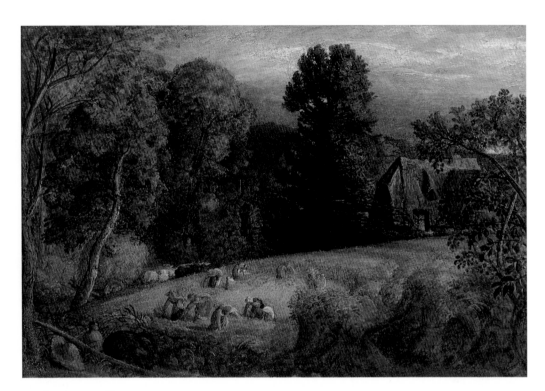

37 *The Gleaning Field*
c.1833
Tempera on panel
30.5 × 45.4
(12 × 17⅞)
Tate

2

MIDDAY:
THE PIT OF MODERN ART

For the first part of his career, until he succeeded in gaining election to the Society of Painters in Water-Colours in 1843, Palmer's fortunes in the various exhibitions in London – and beyond – were extremely mixed. His reaction to the frequent indifference towards his work from fellow artists, critics and public was similarly variable: at times he affected disdain towards the contemporary art world, while at others he appeared resigned to support himself by teaching, and paint only for love. Underlying both these attitudes is an almost wilful self-reliance and an apparent refusal to compromise. This did not prevent him, however, from making substantial shifts in his position towards various fundamental aspects of his art, such as the importance of drawing or the status of classical culture. His continuing process of self-education and self-discovery as an artist accounts for these revisions in part; but they are also a result, more than Palmer himself might have liked to admit, of changing circumstances, not only artistic but also social.

In 1824 Palmer claimed that 'it pleased God to send Mr Linnell as a good angel from Heaven to pluck me from the pit of modern art'.[1] This may have changed forever his desire to succeed within the prevailing conventions of sub-picturesque painting and prompted the deliberately archaic style associated with the Shoreham years. It did nothing, though, to bolster the public reputation the young artist was beginning to establish. Indeed, for nearly twenty years, the very reverse was true.

Palmer was evidently so thrilled by the sale of one of his first exhibited pictures from the British Institution in February 1819 that he preserved the scrappy note from the secretary informing him of the event until the end of his life; it is now in the National Art Library. Three years later, Robert Hunt, the critic of *The Examiner*, who had written sympathetically about Constable's *Landscape: Noon (The Hay Wain)* shown in the same exhibition, noticed Palmer's *A Lane Scene, Battersea* at the British Institution. He praised the 'touches at once so spontaneous and true, and light so unostentatiously lustrous' of a painting that is now lost, but may have resembled the work of successful Academicians such as Augustus Callcott or William Collins.[2]

Apart from 1822, when all his submissions may have been rejected, Palmer showed at least one work each year at the Royal Academy. Novices found it less easy to gain attention at this prestigious venue, and it was not until 1825 that he again came to the notice of the press. The works entitled *A Scene from Kent* and *A Rustic Scene*, exhibited in the 'Anti Room', are likely to have been paintings rather than any of the drawings dated to this year. Neither can be secure-

ly identified today, but they must have embodied Palmer's earliest responses to the landscape around Shoreham, which he appears to have visited for the first time in 1824. Presumably, like the drawings, they reflected all the enthusiasm of Palmer's recent encounter with Blake. The critic of the nationalistic weekly *John Bull* was so fulsome in his praise that one suspects a hint of irony. For 'the skill and power of execution', Palmer's paintings 'stand unrivalled in the department of art to which they belong'; they possess 'a clear and brilliant light and a vivid style of colouring which it would be vain for any other artist to hope to equal'. The critic concludes 'we recommend every visitor to the exhibition to seek out these gems, which need only to be seen to be appreciated'.[3] The free use of brilliant colour is evidently a radical departure from the gentle illumination of the earlier landscapes, and seems to prefigure the most extravagant Shoreham works such as *The Magic Apple Tree*. The double-edged tone of this criticism is more apparent in the light of another notice about the same works, which appeared in the *European Magazine*. 'There are two pictures by a Mr Palmer, so amazing that we feel the most intense curiosity to see what manner of man it was who produced such performances. We think if he would show himself with a label round his neck "The Painter of A View in Kent" he would make something of it at a shilling a head. What the Hanging Committee meant by hanging these pictures without the painter to explain, is past our conjecture.'[4] Fortunately, perhaps, for Palmer, this cruel review did not appear until the September issue, by which time the exhibition was long over. It was to be several years, though, before Palmer again showed paintings at the Academy. The episode may well have influenced his decision to submit mainly monochrome drawings, which rarely attracted any critical comment whatever.

In 1827 and 1828, everything Palmer sent in was rejected. In 1829, to his own astonishment, of eight works submitted, two drawings were hung which he had thought 'far least likely'. By his own admission, *The Deluge: A Sketch* (untraced) and *Ruth Returned from Gleaning* (fig.18) continued in the vein of his 'wonted outrageousness', for which he was evidently unrepentant.[5] The distortions of the figure of Ruth have already been noted. The spatial organisation is equally idiosyncratic, with what appears to be a figure reading by candlelight in a hollow beneath Ruth's feet, and a tiny form in white standing on the hillside in the distance, towards which Ruth appears to be heading. Most disturbing of all, perhaps, especially for an exhibited drawing, and one not even excused by the designation of 'sketch', is the evidence of quite different ideas in the underdrawing embedded beneath the present surface. Palmer must have had such faith in his powerfully Michelangelesque figure that he believed he could not only get the drawing past the selection committee, but that, even in its unfinished state, it could have some impact on the visiting public. There was no danger he would succumb to the excessive descriptiveness of the great mass of literary painting, the trend soon to be lambasted by Charles Lamb in a series of articles entitled 'On the total defect of the quality of imagination observable in the works of modern British artists'.[6]

In 1829, *Ruth* was hung in the Antique Academy, usually crowded with drawings so badly arranged that 'some of the works exhibited might just as

well be hung with their faces to the wall'. After two more years showing nothing, his drawings again apparently rejected, in 1832 he showed no less than seven works, though again in the Antique Academy, likened by the same reviewer to 'purgatory, if not a worse place'.[7] Some of these were the Indian ink compositions Palmer described as 'my blacks'. *The Flock and the Star* (fig.38), possibly one of them, exhibited as *A Pastoral Scene – Landscape*, is much more carefully finished than *Ruth*. It demonstrates a refined sense of touch, while retaining a certain naive quality in the compartmentalisation of space. Three of the drawings were twilight scenes. These monochrome compositions show Palmer's love of half-light as a time for imaginative reflection. Within the context of the exhibition, they must also have appeared as a refusal of the flashy brilliance usually required to attract attention. Needless to say, they do not appear to have aroused any critical notice.

Evidently encouraged by his showing of seven drawings at the 1832 exhibition, in 1833 Palmer decided to chance submitting oil paintings again. One was probably *The Gleaning Field* (fig.37); another was *The Harvest Moon* (fig.39), and both were hung in the Great Room, where the majority of visitors congregated. These small paintings were not hung above head height, where they could easily be seen, but must have been placed on the flat, lower part of the wall. This allowed a closer, more intimate inspection of the works, which certainly suited Palmer's laboured handling of paint and subtle contrasts of tone. Competition in this great arena was fierce, however, and Palmer, hung in close proximity to Turner's *Childe Harold's Pilgrimage* (Tate), found that he was literally overlooked.

The experience of showing in the Great Room may have given Palmer the confidence to send work the following winter to the British Institution, after a ten-year break. As was often the case, these works may well have been the oil paintings not sold in the Royal Academy, but the titles (*Landscape* and *A Study from Nature*) are too general to permit identification. In 1834, the Academy Hanging Committee included Linnell's old friend William Mulready, and again Palmer was to be found in the Great Room, though once again, it seems, overwhelmed by a huge canvas of Turner's (*The Fountain of Indolence*, Beaverbrook Foundation, Canada). Even though he failed to make any impression on the critics, he might have found some comfort in the comments of the Athenaeum reviewer, who wrote that 'Pictures of a domestic kind, and landscapes, with lakes and hills and cattle, are numerous, and many of them are excellent; some of the smallest seem the best. There is everywhere a closer observance of nature than usual; but there is not more elegance than before, and little – too little – of that rare quality, imagination.'[8] There is a suggestion that Palmer's small-scale scenes of rural life could be taken seriously by an intelligent critic. His previous experience should now equip him to discover that elusive fine line between the study of nature and the exercise of the imagination.

39 *The Harvest Moon*
1833
Oil on paper laid on panel
22.2 × 27.6
(8¾ × 10⅞)
Yale Center for British Art, Paul Mellon Collection

But Palmer would not wait for the public taste to wake up to his own particular talent. Disillusioned by rural life, partly as a result of the political events of 1832, partly by the growing realisation that he must simply work harder to achieve the recognition he desired, he acquired a house in London, and alternated between the capital and the country. 'What is done at leisure is done wrong', he suggested to Richmond in the autumn of 1834. His previous letter had been more explicit about his 'wishing as soon as possible to struggle up into repute'.[9] This growing sense of urgency led Palmer to go to Devon in the summer of 1834 to look for landscape motifs of a different kind, more dramatic and eye-catching than Kent. In the autumn he was back in Shoreham, experimenting in painting in oils out of doors. *Farmyard and Shaded Stream, Shoreham* (fig.40) seems to be a product of this year. It may well be the painting that was touched up by John Linnell over four separate days in December and January 1834–5, prior to its exhibition at the British Institution, where it was entitled either *A Scene near Shoreham, Kent*, or, perhaps more likely, *At Filston Farm, Kent*. The painting may well have sold. When it came to light again forty years later, Palmer and Linnell both accepted it as a joint work, and Linnell, never one to let well alone, worked on it again. This was not to be the last time that Palmer took paintings to Linnell for him to finish – evidence of continuing dependence on his mentor, but also of a certain defeatism, as if Palmer

41 *The Wayside
Smithy c.*1835
Pencil and ink wash
on paper
12.7 × 10.2 (5 × 4)
Yale Center for
British Art, Paul
Mellon Collection

still felt inadequate when it came to adding the final touches that would bring
the entire work into focus. Despite its hybrid authorship, this painting
deserves serious consideration. The composition is undoubtedly Palmer's
own. It is ambitious in its rendition of sunshine penetrating a thick canopy of
foliage, precisely the 'chequer'd shade' (the phrase is Milton's, from *L'Allegro*)
that became a hallmark of his later watercolours. The vagrant family (proba-
bly added by Linnell), situated on open ground outside the paling enclosing
the farmyard, is an important motif which Palmer would also introduce
repeatedly over the years to come. The work charts Palmer's progress towards
a more mundane depiction of the agricultural landscape than the recent har-
vesting subjects. It is a trend also to be found in *The Wayside Smithy* (fig.41),
where the balance of different light sources and the delicately drawn trees pro-
vide the poetry Palmer was always seeking to extract from landscape.

 Palmer's development as a painter in oils and his quest for more rugged,
variegated landscape subjects (more in conformity with the typical 'lakes, hills

and cattle' of the 1834 Athenaeum review) can be seen in two works datable around 1835, *Autumn Landscape with a View to the Sea* and *The Waterfalls, Pistil Mawddach* (figs.42 and 43). The exquisite small coastal scene has some of the features of North Devon, which Palmer visited in 1834. (It has recently been proposed this may be the *Scene from Lee, North Devon* exhibited at the Royal Academy in 1835.[10]) The dazzling sunlight reflected on the sea, rendered in solid pure white paint, provides a highly dramatic gesture to act as a counterpoint to the milder vignettes of harvesters, a shepherd leading a flock down a lane, and wood gatherers, which he introduces into other parts of the landscape. Palmer sketched the waterfall Pistyll Mawddach during a four-week tour of North Wales with fellow Ancients Henry Walter and Edward Calvert in the summer of 1835. 'My pastoral has had a month's stretching into epic' was how he described the journey to George Richmond.[11] This new departure, typically described in literary, as much as in visual terms, was in effect more of a regression. The mountains, lakes and castles Palmer drew this summer, and again the following year, belonged to a repertoire of picturesque and sublime subjects established in the late eighteenth century. They still enjoyed a vigorous afterlife, even in the 1830s, though often inflated to heroic proportions. Palmer's oil painting, though only just over 50 cm across, is, apart from *The Shearers*, the largest that he had tackled since the early 1820s. Two other waterfalls, shown at the British Institution in 1836 and 1837 but now lost, were even larger. Palmer was contemplating a trip to the Lake District in 1837 to draw similar subjects when preparations for his marriage intervened. He was not unhappy to relinquish an approach to drawing nature that within a couple of years he would reject as 'unworkable'. Even though he was deeply insecure about technical procedures, he soon came to the conclusion that 'if I were only multiplying studies in the Welsh manner, I should be miserable'.[12]

Only at Tintern, at the end of the first Welsh trip, did Palmer discover a subject that gave him the opportunity for a deeper cultural engagement. The ruined abbey stirred up his love of Gothic art, one of the cornerstones on which The Ancients had been founded, and with it, a rejection of the classical. 'Grecian is Mathematic Form: Gothic is Living Form' had been Blake's pithy encapsulation of this deep stylistic and ideological divide.[13] Though Palmer studied Tintern from several viewpoints, the sketches never resulted in any finished paintings. Instead, the drawings became monuments to a thoroughgoing reorientation of Palmer's cultural map. From this moment on, he would be drawn more and more to the classical and far less to the Gothic. In 1862, he would write to Richmond's daughter, 'Classical subjects are peculiarly fit to be painted just now, as a protest against the degraded materialism which is destroying art'.[14] All that will remain are melancholy echoes of Tintern and the broken tracery of its east window reverberating through the luscious sunset landscapes of his later years.

Palmer's apparent volte-face has dismayed many later commentators. It was not made in isolation, however, but coincided with a more general re-evaluation of the Greek versus Gothic debate. One of the most important milestones in this, the second phase of the Gothic Revival, was the architect Augustus Pugin's *Contrasts*, published in 1836. It set out to demonstrate the

42 *Autumn
Landscape with a View
to the Sea* c.1834–5
Oil on canvas
26.1 × 38.1
(10¼ × 15)
Fitzwilliam Museum,
Cambridge

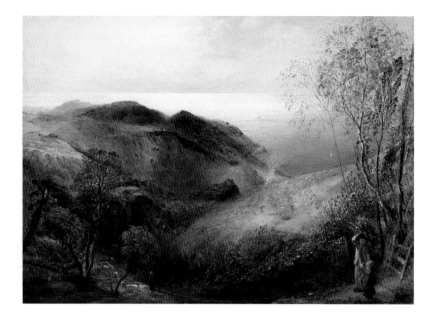

43 *The Waterfalls,
Pistil Mawddach,
North Wales* 1835–6
Oil on canvas
40.6 × 26
(16 × 10¼)
Tate

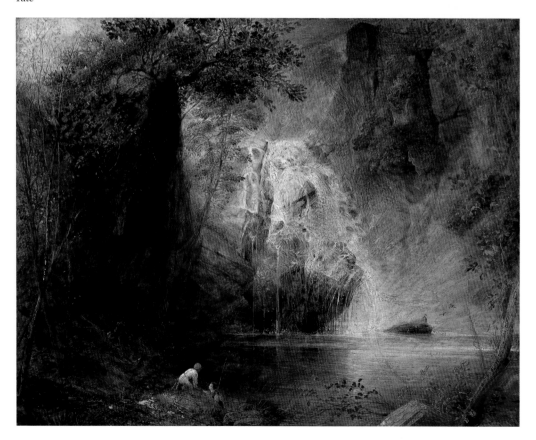

material poverty of modern life in the mid-nineteenth-century city, which Pugin defined as only partly owing to style, or even to economics or politics. For him, the source of society's ills lay in false religion, a view that would have won Palmer's entire sympathy. But where Pugin followed his love of the outward forms of the medieval church to what might appear to be its logical conclusion, and converted to Catholicism, Palmer was to remain staunchly Anglican. Yet as the revival of Gothic architecture became associated with the Anglo-Catholicism of the Oxford Movement, it was harder for Palmer to employ the church, now a hotly contested realm, as an emblem of simple traditional values. Conventional in his faith, but combative and oppositional in other respects as the 1832 'Address' shows only too clearly, Palmer looked for other means of expressing his own ideas, and of stirring the embers of the modern imagination, fatally dulled, as he saw it, by an ever-rising tide of materialism. He would surely have been one of the many who identified with Thomas Carlyle's *Sartor Resartus*, a vitriolic denunciation of contemporary attitudes, serialised in *Fraser's Magazine* in 1833–4. This rallying call for a return to old-fashioned belief 'amidst the controversies, the arguments, the doubts, the crowding uncertainties' of the time was highly influential.[15] One of Carlyle's most affirmative images, in a chapter entitled 'The Everlasting Yea', showed an aspiration not dissimilar to Palmer's, with 'straw-roofed cottages, wherein stood many a mother baking bread, with her children round her: – all hidden and protectingly folded-up in the valley folds'. For Carlyle, as for Palmer, the only possible basis for such a society was faith in God.

Palmer's decision to go to Italy in the autumn of 1837 was not in itself to be the cause of the radical change that took place in his art. Italy confirmed and strengthened attitudes already developing in his mind, and was expected to equip him for the years to come. What Italy provided was not so much a repertoire of specific images, even if that is what was envisaged at the time, as a sense of familiarity with the traditions of high culture which it still embodied. Whatever Palmer had learnt in nearly twenty years of artistic endeavour, he now wanted to unlearn. He was starting again – from scratch.

On 30 September 1837, Palmer married John Linnell's eldest daughter, Hannah, who was then aged nineteen. Four days later they embarked for Italy, accompanied by George Richmond, his wife and young son. Richmond provided a substantial loan to Palmer, reciprocating the gesture Palmer had made at the time of his friend's marriage in 1829. Further funds were to be provided by Linnell, who commissioned Hannah to colour engravings of frescoes by Raphael and Michelangelo in the Vatican. This arrangement, seemingly practical and educational, while also ensuring that Hannah would be gainfully occupied, proved to be a millstone around the couple's neck.

The regular letters that passed between the newly-weds and the entire Linnell family over more than two years until the couple's return in November 1839, have ensured that this period is more fully documented than any other part of Palmer's career. The letters make rather uncomfortable reading, however. The warmth and mutual respect that had existed between Palmer and Linnell over many years now began inexorably to disintegrate under the stresses of their new roles as son-in-law and father-in-law. Palmer's earlier

self-confidence all but evaporated. He undertook the trip with the expectation that his art would change, but it was perhaps the full weight of this expectation that almost paralysed him. The most basic aspects of his method all necessitated lengthy correspondence. Should he draw entire scenes or only details? Should he concentrate on foregrounds or backgrounds? Should he draw figures on the spot or in the studio? Linnell was required to provide ad hoc answers to problems most students would have resolved long ago.

This was a momentous time for Palmer, personally and artistically, and if he was overwhelmed by the visual and cultural riches of Italy, it is not entirely surprising. In Rome, especially, he was not the first to feel the need for a sort of double vision to do justice to a city that appeared simultaneously ancient and modern. Palmer plunged into his work with two complex panoramic drawings. One showed the Forum, viewed from the Capitol, the other, part of a carnival procession against the background of the Piazza del Popolo (fig.44). The idea of producing contrasting pairs of works depicting classical and contemporary Rome had been common at least since Panini and Piranesi in the mid-eighteenth century. Coincidentally, just as Palmer was completing his watercolours in the spring of 1838, Turner hung two Italian subjects at the Royal Academy, *Modern Italy – the Pifferari* and *Ancient Italy – Ovid banished from Rome* (BJ 374 and 375). Palmer was certainly intrigued on receiving the news and wrote back, 'I should like much to know which was the point of difference ... was it in the figures or buildings or both?'[16]

44 *Modern Rome during the Carnival*
1838
Watercolour and bodycolour on paper laid on board
40.9 × 57.8
(16⅛ × 22¾)
Birmingham Museums and Art Gallery

The requirement for Hannah to work in the Vatican meant that the couple stayed much longer in Rome than they intended. Palmer's own needs would probably have been better served if they had spent longer in the countryside. When they did eventually travel south, to Naples and Pompeii, it was in June 1838, at the hottest time of the year. They took refuge from the insects that plagued them at Pompeii and from Vesuvius, then threatening to erupt, in the mountain hamlet of Corpo di Cava. The artist Edward Lear, with whom they had shared a hotel in Naples and who was also then trying to educate himself in the practice of landscape drawing, had visited La Cava in June; it was possibly he who recommended it to the Palmers. Once there, Palmer wrote to Richmond in Florence, they were 'apt to stick'.[17] Hannah, too, was now producing sensitive, freely coloured sketches, developing an artistic personality distinct from her father's as well as her husband's. Surrounded by wooded hillsides, crowned with the simple shape of an ancient monastery that made him think daily of Titian or Poussin, Palmer produced one 'large drawing [and] about a dozen smaller subjects besides hints, outlines and memoranda in my little sketchbooks'. At last he felt he had achieved a breakthrough: 'I now see my way and think I am no longer a mere maker of sketches, but an artist'. Virtually nothing survives from this happy period, except one coloured study of the nearby hermitage, La Vocatella (fig.45). This seems to represent Palmer's best attempt at the 'finished drawings with effect, foreground and figures quite settled' that he believed would be most useful on his return.[18] The study formed the basis for a finished watercolour exhibited in 1845 (untraced; Lister 1988, no.392).

The Palmers returned northwards in preparation for a second winter fulfilling Linnell's commission, but first spent several weeks outside Rome, at Tivoli. It was there, buoyed up perhaps by what he felt he had achieved at La Cava, that he produced some of his best work in Italy. His studies of the cypress alley at the Villa d'Este (fig.46, and one of the trees alone, in the Yale Center for

45 *La Vocatella: A Chapel Built by a Hermit near Corpo di Cava* 1838
Watercolour on paper
26.7 × 36.5
(10½ × 14⅜)
Graves Art Gallery, Sheffield

46 *The Villa d'Este from the Cypress Avenue* 1838
Black chalk and watercolour on paper
45.7 × 31.9 (18 × 12½)
The Pierpont Morgan Library, New York, Gift of the Fellows

British Art) are highly effective where he is able to concentrate on a single motif he had great feeling for – namely, the trees. When he tries to incorporate them into a more ambitious composition, the result becomes purely routine, with prosaic description substituting for poetic intensity (fig.47). Palmer may well have intended to emulate 'that light and pleasing construction which people like to have on their walls',[19] which he said was his aim in one of his drawings of Pompeii. The result is only diffuse.

The cypress studies show Palmer putting into practice the 'good deep greens' which he felt he had discovered in the south, and which contributed to the special power of the landscapes of Titian.[20] By the time he reached Florence, bound for home, in September 1839, his conversion was complete. 'I am wholly absorbed in art and so imbued with love for the landscapes of Giorgione and Titian that I can never paint in my old style again – even though I may paint worse', he declared to Linnell. Focused on his return to London, and the works he intended to paint for the exhibition, he desired only 'a little leisure to try – sink or swim. Poetic landscape [no]t crome and cobalt – but to make one humble effort after deep *sentiment* and deep *tone*'.[21] There is an admission here that the brash colours he had used previously had done him no good, but in other respects the experience of Italy has not changed him at all. Poetry and sentiment, those two elusive qualities he had sought as a teenager with The Ancients, still remain uppermost in his mind.

Once settled back in London, the reality was harsher than he had dreamt. There was almost no interest in his Italian subjects. Just one watercolour made it into the Royal Academy in 1840. Some of this may have been owing to Palmer's loose handling, which by most standards still lacked finish. Equally significant, perhaps, was his miscalculation of the increasingly fickle taste of the exhibition public. Italy could no longer be relied on as an irreproachable standard of artistic excellence. A desire for more exotic fare, fed by J.F. Lewis's views of Spain and David Roberts's scenes of Egypt, unveiled at the Royal Academy in 1840, began to assert itself. For the Athenaeum critic, these novelties appeared not a moment too soon: 'Italy has been painted out and out, and we are weary of its splendid scenes and contemptible people.'[22]

Palmer was forced to rely again on teaching, as he had done before his marriage, and was again beholden to Linnell, and also to Richmond, for most of the necessary introductions. When Linnell took his family to Underriver for a holiday in 1843, Palmer joined them. The landscape he knew so well still had the capacity to inspire him. The *View from Rook's Hill*, on the crest of the ridge overlooking the Weald (fig.48), is one of very few studies of these years to show Palmer trying to apply the lessons of Italy, uniting deep green foliage, foreground figures and a distant cloudy sky on the same sheet. The echo of the compositional format of one of the succesful Villa d'Este studies is probably not accidental.

The most explicit attempt to reawaken the 'Shoreham feeling' is to be found in *The Rising of the Skylark* (fig.49), a small painting based on an idea sketched

47 *The Villa d'Este, Tivoli* 1838–9 Watercolour and bodycolour on paper 27.3 × 37.3 (10¾ × 14⅜) Victoria and Albert Museum, London

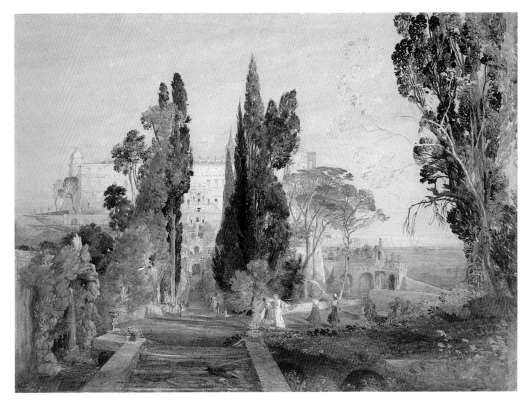

48 *View from Rook's Hill, Kent* 1843
Watercolour with bodycolour, pen and ink over pencil on paper
52.1 × 41.6 (20½ × 16⅜)
Yale Center for British Art, Paul Mellon Collection

in the early 1830s. In the initial study (untraced; Lister 1988, no.140), and in the etching that followed in 1850 (Lister 1988, no.E2), the figure wears dark clothing or a labourer's smock. In the oil, however, the man is not a country dweller, but is dressed in a coloured robe with a white shirt, open at the neck. There is more than a passing resemblance to the portrait of Shelley by Joseph Severn, a friend of Richmond's whom Palmer had met when he first arrived in Rome. Could Palmer have intended this as a new type of modern literary painting, depicting Shelley's most famous lyric in the twilight setting he himself found most poetic? Palmer's other recent attempt at a pure figure subject, *Job Sacrificing*, painted in 1840–1, had not been a success. This must have been all the more galling when Linnell proved able to find buyers for his own religious paintings. Even though Linnell was called in to work on *Job Sacrificing* in 1845, its faults could apparently not be remedied, and it has not been seen or heard of since. As for Shelley's *Skylark*, if this ever was in Palmer's mind, he

57

revised his opinion of the poet's 'blithe spirit'. He wrote to Mrs Richmond in 1866: 'Shelley, if I remember, assures that bird that after all he is no lark at all but a spirit! A spirit! "I say – none of that!" the bird might have replied.'[23]

While still in Italy, Palmer had envisaged membership of the Water-Colour Society as a fall-back option if his ambitions as an oil painter came to nothing. The annual exhibition, reserved exclusively for its forty or so members, would at least guarantee him regular exposure, something he had never yet managed to achieve, even in the inferior spaces of the British Institution, the Society of British Artists, or even Manchester and Liverpool, where he also sent paintings. The news of his election in February 1843 must have been received with relief as much as pride. Already one potential pupil had enquired whether he belonged to the Society, as a guarantee of respectability as much as of the quality of his work. For the rest of his life, this was to be the main platform on which his public career as an artist would be played out.

49 *The Rising of the Skylark* c.1843
Oil on panel
30.8 × 24.5
(12⅛ × 9⅝)
National Museums and Galleries of Wales

3

SUNSET:
BARBARIANS AND PHILISTINES

J.L. Roget, in his 1891 *History of the 'Old Water-Colour' Society*, singled out Palmer as the artist who 'alone sought after and cultivated the ideal'.[1] Yet it was to be several years after Palmer's debut with the Society in 1843 before his distinctive contribution began to be recognised, still less appreciated. Only during the 1860s, after twenty years of patiently representing and reformulating cherished notions about rural life and the visual language appropriate to portray it, did he come to be acknowledged as the leading exponent of the imaginative landscape. One might almost say the only exponent, as his was virtually a one-man crusade. He was not entirely isolated, however, since the values he espoused so single-mindedly in his paintings and prints gained prominence through the work of certain writers and critics whose views mirrored his own. Palmer the Victorian was far from being the spent force wallowing in nostalgia and self-pity that he sometimes appears to be in the biography compiled by his son. He was remarkably in tune with his times. How much of this was owing to self-conscious modernity and how much to the persistence of a common cultural inheritance, this chapter should help to elucidate.

The Water-Colour Society that Palmer joined in 1843 still contained some of the founder members who had participated in the very first exhibition in 1805, the year of his birth. It was dominated, however, by a slightly younger clique of landscape painters, David Cox, Peter DeWint, and the President Copley Fielding, all pupils of another of the founders, John Varley, who had died the previous year. Francis Oliver Finch, one of The Ancients, was also a member. Together with George Barret (whose death in 1842 created another of the vacancies Palmer applied to fill), Finch had for many years supplied the annual exhibition with poetic landscapes heavily dependent on Claude or occasionally, in Finch's case, on Salvator Rosa. As one critic noted in 1835, these never varied from year to year, yet why should they, when they were perfect of their kind? The Society's elderly Secretary, Robert Hills, had even been to Shoreham or nearby. His paintings of Kentish farmyards or of ox teams on the North Downs were evidently popular (fig.50). It seems that on one of his sketching expeditions locals had referred to him as an 'Extollager', the term of affectionate abuse by which Palmer and The Ancients were known.[2] He probably came across the group, though without actually associating with them. Another of the founder members whose idealised paintings of pastoral life would have interested Palmer was Joshua Cristall. One of his favourite motifs, a female reaper with a bundle of corn on her head, was later used repeatedly

50 Robert Hills
A Cornfield 1838
Watercolour
38.1 × 49.5
(15 × 19½)
Private collection

by Palmer (compare Cristall's *Study of a Country Girl with Sheaves* with Palmer's *The Return from Gleaning*, (Lister 1988, no.621).[3] Towards the end of his life, Palmer recalled Cristall as a 'friend'.[4] Linnell, however, was scathing of Cristall's 'Gods and goddesses after the most approved conventional second-hand greek model', though he did concede that occasionally his nature studies showed 'considerable power of design and expression', even if 'he had no power of finish in realisation of details'.[5] These are the very things that came to preoccupy Palmer, to whom Cristall must have stood as both an example and a warning.

With so many apparent affinities between his own art and the existing members of the Society, Palmer may reasonably have expected his contributions to benefit from greater understanding and appreciation than in the free-for-all of the Royal Academy. However, many of the critics who regularly reviewed the annual exhibition did not even comment on the new arrival. From his quota of eight paintings, only three sold, and two of those were to a neighbour of Linnell's. Palmer seems to have decided to take matters into his own hands and arrange a direct meeting with a rising young critic who in 1843 published a book entitled *Modern Painters*: John Ruskin. Ruskin had become very friendly with George Richmond, who had been painting his portrait in 1842 while *Modern Painters* was being written. It was presumably Richmond who arranged for Ruskin to see Palmer's drawings. This meeting took place in 1842, but Ruskin chose not to refer to it until some time later, when Palmer was at least established as a member of the Water-Colour Society. Palmer showed Ruskin the copy of a landscape by Giorgione he had made in Florence. He must also have produced some of the studies of trees he had made in Italy, including those of the Villa d'Este (fig.46). These were an impor-

tant element in Palmer's pursuit of greater finish and struck a chord with Ruskin's relentless insistence on the careful observation of nature. Ruskin added a paragraph to the end of the chapter entitled 'Of Truth of Vegetation' when the third edition of *Modern Painters* was published in 1846. He began with Linnell, but reserved his greatest praise for Palmer, a 'less known artist [who] is deserving of the very highest place among faithful followers of nature. His studies of foreign foliage especially are beyond all praise for care and fullness'.[6] It is ironic that Ruskin should have expressed such wild enthusiasm for work that Palmer created only as a means to an end. The excessive naturalism that *Modern Painters* later inspired is far removed from Palmer's conception of the poetic landscape. One can only deduce that Palmer did not live up to Ruskin's expectations of him, for he is hardly mentioned in later criticism. This one paragraph seems to have served its purpose, though, as far as Palmer was concerned. There are certainly many more critics who appear to take notice of him in the wake of Ruskin's comments. Twenty years later the effect was still being felt. The *Art Journal* in 1866 commented: 'Mr Ruskin in past years pronounced this artist the coming man. Accordingly Mr Palmer now realises the prediction.'[7]

Ruskin's approving comments came not a moment too soon. After initial successes with Italian subjects in his first two years, he sold nothing in 1845. Palmer changed tack, and in 1846 reverted to the farms and harvesting scenes

51 *Harvesting*
c.1850
Watercolour and
bodycolour over
pencil with gum
arabic on paper
37.8 × 51.5
(14⅞ × 20¼)
National Gallery of
Art, Washington.
Gift of the Brown
Foundation, Inc.,
Houston

52 T. Hollis, after
O. Oakley
The Gypsy Camp
Wood engraving
25.3 × 20.5
(10 × 7⅞)
Witt Library,
Courtauld Institute

he had shown regularly in the previous decade. At first these, too, were all returned to the studio. Shown alongside watercolours by Cox and DeWint, who had developed over many years an ease and fluency in the treatment of such material, Palmer must have appeared rather laborious, his effects achieved at too great a cost. 'ABOLISH all NIGGLE', he admonished himself in a notebook of 1850.[8]

Harvesting (fig.51) may well be the work exhibited in 1850 as *Carting the Wheat – Showery Weather*. After a period of agricultural depression, the repeal of the Corn Laws in 1846 offered better prospects for the rural poor. Harvesting scenes provided the urban picture-buying public with affirmative images of the countryside at the climax of its annual cycle. Such subjects were now less politically divisive than when the benefits to the country as a whole seemed to be achieved at the expense of the poorest in society.[9] Tories opposed the changes, unwilling to concede any of their traditional privileges. Palmer here appears sympathetic towards the harvesters, who battle to complete their task despite the threatening conditions. Most paintings of the English countryside chose to emphasise its stability and continuity and the simple virtues of its inhabitants. The very real privations of rural life did begin to emerge, obliquely, through an increasing number of pictures of one of the most marginalised groups of country dwellers, the gypsies.

Octavius Oakley, elected to the Water-Colour Society in 1842, the year before Palmer, made a speciality of character studies of gypsies (fig.52). These were paralleled by Francis Topham, who produced a string of similar works for

the New Water-Colour Society, beginning the same year. Palmer's nocturnal pranks with The Ancients around Shoreham, and his long sketching tours when he slept under hedges and in isolated barns, had given him a taste of this way of life. The watercolour he exhibited in 1847, *The Gypsy Dell: Moonlight* (fig.53), shows an awareness of a topical subject, coupled, one might imagine, with a disguised fragment of autobiography of his own.

The following year Palmer found another way of tapping his private enthusiasms, while further diversifying the subjects he presented at the Water-Colour Society, and this was through paintings based on popular literature. He began in 1848 with one of his favourite authors, John Bunyan. *Christian Descending into the Valley of Humiliation* could well be seen as a commentary on his current status as an artist (Ashmolean Museum, Oxford). He felt 'miserably hampered' by the teaching on which he depended for a regular income. The watercolours that he did show were often badly placed, and his continuing appearance on the list of 'Associates' when almost all the other recent arrivals had been promoted to full membership was a 'sort of public annual stigma'.[10]

In 1850, Palmer chose a subject from *Robinson Crusoe*, 'a book', George Borrow claimed, 'which has exerted over the minds of Englishmen an influence certainly greater than any other of modern times'.[11] For the setting Palmer devised a rocky shoreline, ultimately derived from the coastal scenes of Claude, but based on studies made in Cornwall in 1848. The most spectacular

53 *The Gypsy Dell: Moonlight* 1847
Watercolour and bodycolour on paper
38.4 × 51.3
(15⅛ × 20¼)
The National Gallery of Scotland, Edinburgh

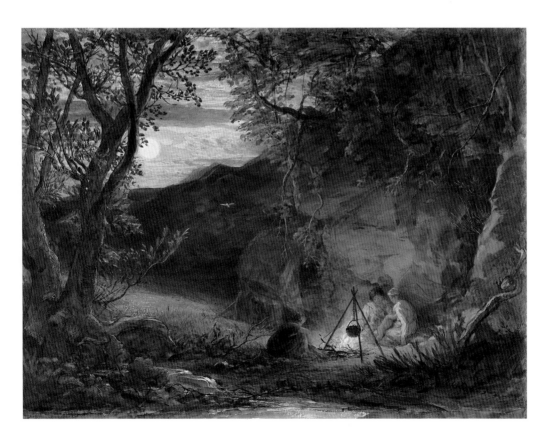

location he drew was undoubtedly Tintagel, the castle associated with Arthurian legend standing on an exposed headland on the north Cornish coast. The finished painting he worked up for the 1849 exhibition (fig.54) adopts a similar viewpoint to Turner's treatment of the same subject, engraved for the series *Picturesque Views on the Southern Coast of England* in 1818. But where Turner's foreground incident depicts mineworking, Palmer wedges into the right corner a coastal path with a cart, perhaps derived from Turner's view of Dartmouth engraved in 1825 for the *Rivers of England*. There is no hint of this in the study, now in the British Museum. Palmer was adopting the tactic of many of his colleagues in the Water-Colour Society in studying the engravings of the most celebrated landscapist of modern times. When Palmer sat next to the great man at a birthday dinner at Ruskin's in 1847, it was a never-to-be-forgotten landmark in his emergence as a mature artist.[12]

For three weeks Palmer made sketches of the sun setting over the western sea, and these provided the material for many subsequent compositions. At first, they were almost too much for the critics to take. 'What shall we say to Mr Palmer, who with certain evidences of talent and a dream of truth offers us such eccentricities of prismatic colour run mad?', commented one reviewer of *Robinson Crusoe Guiding his Raft up the Creek* (The Potteries Museum, Stoke on Trent), reiterating, almost verbatim, the reactions of the 1820s.[13] For Palmer, however, these coastal settings represented an ideal marriage of characteristic landscape with an appropriate 'effect', something he had been looking for in Italy and ever since. There was also a strong personal association

54 *Tintagel Castle (Approaching Rain)* 1848
Watercolour and bodycolour on paper
30.3 × 44 (11⅞ × 17⅜)
Ashmolean Museum, Oxford

behind what was to become an often repeated formula. 'Why, from childhood onwards, are we ever dreaming of capes and caves, and islets and headlands and the marriage of land and sea?', he wrote to his friend the marine painter J.C. Hook in 1863.[14]

It is one thing to employ this format, as Palmer does initially to depict an incident from *The Odyssey* (*Farewell to Calypso* 1849; Whitworth Art Gallery, University of Manchester), then adapt it to Crusoe's tropical island. He might appear to stretch credibility, though, when he presents a contemporary subject in the same manner, as he does in 1858 with *Going to India – the Father's Blessing and the Mother's Prayer* (fig.55). Nothing could be further from the crowd-pleasing patriotism of other artists' responses to the Indian Mutiny of 1857, such as Henry O'Neill's *Eastward Ho, August 1857* or Noël Paton's *In Memoriam* (exhibited in August 1858 and 1859 respectively).[15] What Palmer reveals by this strategy, more tellingly than ever when the theme is so topical, is the mythic dimension to everyday life. The pretext may be modern, of the moment, but the emotional truth, the real business of the artist, is timeless. The remarks that Palmer wrote to the critic F.G. Stephens in 1875 crystallised opinions he had held for many years: 'It is just now the fashion to say that great geniuses have been distinguished by their sympathy with the then present. I think their works have always synchronised with the past, though as men and moral agents it is to be hoped they sympathised with people about them and did what good was in their power. A preference for the present as a matter of taste is a pretty sure sign of mediocrity ... But Johnson teaches us that "whatever makes the past, the distant or the future predominate over the present advances us in the rank of thinking beings".'[16]

55 *Going to India – the Father's Blessing and the Mother's Prayer* 1858
Watercolour and bodycolour on paper
19.4 × 42.9
(7⅝ × 16⅞)
The Victoria and Albert Museum, London

Palmer's tactic of engaging contemporary issues and then providing a resolution of a sort by relocating them in some remote time and space was not unique. Ruskin's *The Stones of Venice* was as much a diatribe against the modern mercantile ethos of the Victorian city as it was a history of the art and architecture of the maritime republic. One of the most influential statements of this kind was the poet and critic Matthew Arnold's *Culture and Anarchy*,

published in 1869. Arnold argued that in the modern age culture had all but vanished. The models to emulate were long gone: ancient Greece, early imperial Rome, the High Renaissance. Nowadays, society was dominated by Philistines, the middle classes. He identified the Barbarians as the old aristocracy, whose influence was not necessarily destructive; it was they, Arnold felt, who possessed the capacity to reinvigorate a decadent age through a 'back to basics' campaign of good manners and healthy living. Although they could not fill the cultural vacuum that threatened Britain's very make-up, they could at least prepare the ground.

Palmer, highly literate as he was, already knew of a much earlier description of the northern Europeans as latter-day 'Barbarians', coined by the Renaissance scholar Erasmus. During the 1860s, Palmer's letters contained several references to the 'Barbarians' of modern times, and so when the chapters of Arnold's book began to appear as separate essays in 1867, Palmer recognised the frame of reference at once. He was highly approving of Arnold's analysis, writing to a clergyman friend a year later: 'Blessed was the day in which Matthew Arnold christened us "Philistines"'.[17] Palmer would have applauded Arnold's insistence on the intellectual quality of true culture when he wrote: 'The idea of perfection as an inward condition of the mind and spirit is at variance with the mechanical and material civilisation in esteem with us.'[18] Where he could not follow Arnold, a self-confessed Liberal, was in his approach to religion. Although Arnold allowed for the importance of religion, itself a sensitive issue in an increasingly secularised society trying to come to terms with Darwinism, he did not accord it any unique status. In dividing mankind into Hebrews and Hellenes, those who want to act rightly, or those who want to think rightly, he found both equally valid. Palmer, meanwhile, maintained his unshaken belief in a transcendent deity. As he got older, this faith became an increasingly private matter, not something he felt able to voice directly through his painting. The power and magnitude of his belief was expressed most dramatically in his comments on an event which inspired the last of his topical watercolours, the appearance of Donati's comet.

Palmer saw the comet on Dartmoor during a trip to Devon and Cornwall with his eldest son, Thomas More, in September and October 1858 (see fig.56). He exhibited the subsequent painting the following year at the Water-Colour Society, where it was joined by a work by William Turner of Oxford entitled *Near Oxford – Half past 7 o'clock P.M., Oct 5 1858* (Yale Center for British Art). This painting also depicted the comet, although the artist chose not to mention it in the title, recording instead the moment when it gained its greatest brilliance. The following year, the comet also featured in an oil painting by William Dyce shown at the Royal Academy, *Pegwell Bay: A Recollection of October 5th 1858* (Tate). In Palmer's watercolour, a mother directs her child's attention towards the comet, while a shepherd gazes on at the extreme left, his flock gilded by the light from the flaming tail. To the right, in one of Palmer's nooks, a woman sits reading by candlelight. She is a near-relation of the Naomi in *Ruth Returned from Gleaning* and another reminder of the power of the written word, still as important a stimulus to Palmer's imagination as the most spectacular manifestation in nature. In a letter probably written around the time

he was working on the painting (dated January 1858 by A.H. Palmer, but much more plausible as January 1859), Palmer refuses to be impressed by such phenomena, revealing at the same time his highly speculative cast of mind in all things spiritual. His opening remarks are surely sparked off by the comet: 'Planets and systems rolling through millions upon millions of miles of dark, empty space are dismal matters to think on, and repulsive to our human feelings, as crushing man [and] his concerns into less than a point – an atom.' The subject inspires yet deeper reflections. 'I have long believed that these vast astronomical spaces are real to us only while we sojourn in the natural body, and that the soul which has put on immortality will, so far as the soul can be cognisant of space, find itself larger than the whole material universe.' In between comments on electricity and modern railway travel, Palmer shows a visionary appetite for the future just as extraordinary as for the past. 'The rush of the autumnal meteor may be a snail's pace compared with the motive Will of interplanetary travellers.'[19]

Past, present and future are all drawn together in the final phase of Palmer's life through a new sphere of activity for him, that of etching. From his first trial plate in 1850 to the series of illustrations for the *Eclogues* of Virgil he was working on at the time of his death in 1881, he completed a mere thirteen prints. Both imagery and execution are highly original. P.G. Hamerton, the critic who did most to chronicle what has become known as the 'Etching Revival', referred to Palmer as a 'false etcher', in that he used a technique which is essentially linear to create images which are primarily tonal.[20] Hamerton was nonetheless one of the first to recognise Palmer's genius in this field, devoting an entire chapter to him in his seminal *Etching and Etchers* of 1868, when Palmer had published only ten plates. Palmer's artist friend J.C. Horsley was not exaggerating when he told him he was 'the King of the Etching Club'.[21]

It may well have been Palmer's beloved Milton who provided the incentive for him to take up etching in the first place, at least in part. He joined the Etching Club in 1850, immediately after the publication of a new edition of

56 *The Comet of 1858, as Seen from the Skirts of Dartmoor* 1859
Watercolour
31 × 70
(12¼ × 27½)
Private collection

Milton's *L'Allegro* illustrated by eight of its members. The Etching Club was founded in 1838 as a regular gathering of an assorted group of artists keen to develop a technique then associated almost entirely with reproduction rather than with original expression. As well as finding a novel forum for mutual support and criticism, of which several parallel examples existed in the Sketching Society or the Graphic Club, the members soon established an additional source of income by collaborating in the illustration of popular texts: Goldsmith's *Deserted Village* in 1841, the songs of Shakespeare in 1843 and Gray's *Elegy* in 1847.[22] Palmer had made one successful foray into book illustration with the provision of four designs for Dickens's *Pictures from Italy* in 1846. There is no indication that any further offers followed immediately in its wake, and he must have looked on the Etching Club as a means of self-publicity which might also provide opportunities to give vent to cherished ideas on other literary classics.[23] Apart from an expanded reissue of the Shakespeare volume in 1853, which sold badly, the Club's subsequent publications were mixed portfolios. The stylistic disparity among the members was probably too disruptive; at the same time, specialist illustrators were working on similar luxury volumes for the same market, which had a more unified result. *L'Allegro*, together with *Il Penseroso*, was published by David Bogue in 1855 with illustrations by Birket Foster, though these were 'etchings in steel' with more the look of conventional etchings.

The etching that Palmer made to support his application for admission to the Etching Club, *The Willow*, was his first. It was based on a large watercolour study drawn during the previous decade (Manchester City Art Gallery). Four other small plates followed, for which Palmer turned to sketches from his Shoreham years. The artist who as a young man had wanted to paint on ivory and who had a series of small monochrome landscapes accepted at the Royal Academy in 1832 felt immediately at home in this miniature world measuring only 10 × 8 cm. Spared the requirement to use intense colour to attract attention in a crowded exhibition room, he could return to the muted emotion of the 1825 ink drawings, rendered now with the delicacy and finesse of the etching needle, rather than the assertive stroke of a quill pen. The plate of *The Sleeping Shepherd* (fig.57) is the same size as the other subjects completed around 1850, and must have been begun then. It was not published until 1857, however, and shows signs of reworking, with fine hatching giving way to the grainy tone which would be so distinctive in the larger plates which followed. The foreground figure is derived from an oil and tempera painting of around 1833–4 (private collection; Lister 1988, no.179); the posture is loosely based on a marble sculpture, said to represent Endymion, which Palmer had drawn in the British Museum.[24] By the time he came to make the print, Palmer wanted to reinforce the classical aura of the subject, and added the distant ploughman. In Italy he had made a special point of making 'finished studies of a team of oxen (the oxen of Theocritus and Virgil)',[25] which he used in a number of later watercolours. Here it provides a telling contrast that operates on several levels: industry and idleness, agriculture and husbandry, dawn on the hilltop versus the shady bower. In a watercolour that preceded the final composition of *The Sleeping Shepherd* (Fitzwilliam Museum), the

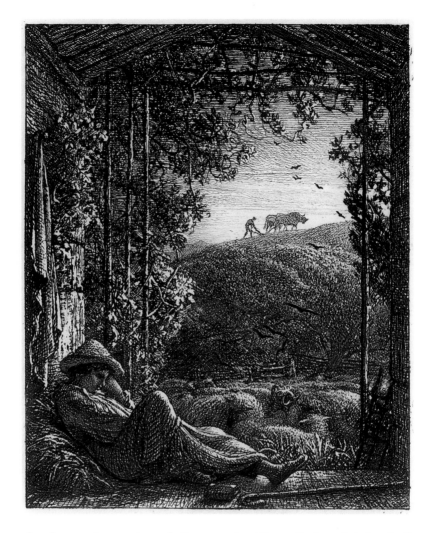

57 *The Sleeping Shepherd* 1850–7
Etching, second state
9.5 × 7.8 (3¾ × 3⅛)
Ashmolean
Museum, Oxford

ploughman advances towards the recumbent figure. In the print, they both face towards the rising sun. In this respect, Palmer unites both as part of a greater dynamic. The dog that accompanies the shepherd in the watercolour is closely related to the one in his early drawing of the same subject (fig.22); in the print it is replaced by a little book. Palmer's rustics are not illiterate peasants. As he knew from his reading of Virgil, and the translation of the *Eclogues* he had begun work on with his son in 1856, Virgil's Tityrus, the shepherd farmer, was himself a poet.

This density of reference, where Palmer is recycling his own past as well as the past of other civilisations, entirely suited his general belief in the decline of culture and the need to restate lasting truths that had stood the test of time, whether across the short duration of his own life or through the centuries. In 1864, he embarked on a series of watercolours for Ruskin's solicitor L.R.Valpy, based on Milton's *L'Allegro* and *Il Penseroso*, two poems whose themes have been neatly summarised as 'mirth and melancholy'. Valpy gave Palmer the freedom to choose his own subjects and the painter opted for texts that had the

distinction of having been recommended by Joshua Reynolds as being full of suggestive imagery for landscape painters.[26] They also had current appeal, as the recent illustrated editions testified. Palmer's interest in them, he told Valpy, went back at least twenty years and he 'once went into the country expressly for retirement while attempting a set of designs for [them]'.[27] The illustrated editions of the 1840s and 1850s set the poems firmly in the context of seventeenth-century Puritanism. Palmer's watercolours deliberately avoid any such specific location; instead, he devised his set of eight subjects as four pairs, evoking different times of day. Visually and iconographically, he intended them to portray the spirit rather than the letter of Milton's text.

Progress on the watercolours was slow. Two were exhibited in 1868 and another the following year, then eight years passed before Palmer would consider the next subjects finished (*A Towered City*; *The Lonely Tower*; *Morning*; *The Waters Murmuring*). Commenting on the recent fashion for exhibiting sketches, which he himself took advantage of by showing work from much earlier trips to Wales and Italy, Palmer defined the pleasure to be gained from such work as almost entirely sensual.[28] The quick fix, deriving gratification from mere appearance, was to him a symptom of the modern malaise. By taking his time, he implicitly sought a more spiritual response, matured through long reflection. Fortunately for Palmer, Valpy acquiesced in the prolonged gestation of the paintings, commenting on the works as they progressed and proposing amendments. The painter's near inertia at the very moment of securing the sort of commission he had wanted for years is unexpected. It was perhaps also a result, indirectly, of the intervention of Linnell. Now a rich and highly successful painter, he bought the Palmers' house on the edge of Reigate and

58 *A Dream in the Appenine* 1864
Watercolour and bodycolour on paper laid on wood
66 × 101.6 (26 × 40)
Tate

allowed them to live there rent-free. The financial pressures that had driven Palmer for years were thus largely lifted, though Linnell's generous action was made more for his daughter's sake than out of any residue of feeling for his son-in-law.

The eight Milton watercolours form a summation of Palmer's entire career as a landscape painter. He deliberately combined images from Shoreham, Devon, Buckinghamshire and Italy to create an idealised world that mirrored that of Claude, though without imitating it. Ruskin now ignored him. The interpolated paragraph was removed from the 1851 edition of *Modern Painters*, on which all subsequent reprints were based. He presumably found, as with Claude, 'no simple or honest record of any single truth; none of the plain words or straight efforts that men speak and make when they once feel'.[29] Feeling, for Palmer, was a more complex affair. Once again, he found himself swimming against the stream. Even his ostensibly topographical paintings, such as *A Dream in the Apennine*, exhibited in 1864, were commonly referred to as 'visions' (fig.58). The painting, for all its sunset glow, is full of the excitement and anticipation Palmer felt on first approaching Florence in 1837. It still maintains his belief in landscape as 'the symbol of prospects brightening in futurity', an attitude deeply embedded through constant reading of Bunyan.[30]

The Milton watercolours are similarly overlaid with personal associations.

The two night scenes are both based on lines from *Il Penseroso*. In the written outline for *The Lonely Tower* (fig.59), Palmer said he wanted to convey 'Mysterious suggestion. More meant than meets the eye. The sleeping fold a sort of comfort, so that there should not be desolation.'[31] The tower he depicted stood on Leith Hill in Surrey. This was near the house where Palmer's eldest son died in 1861, and the place was so full of painful memories that he never visited it again, and could hardly bear to see it, even from a distance. Well might he describe the mood as one of 'poetic loneliness'. His desire to represent it as 'a secluded spot in a genial pastoral country' shows him in his last years applying the healing power of art to his own wounded psyche.[32]

The Bellman (fig.60) is referred to in a letter of November 1864, and could have been one of the first of the series Palmer tackled. He was never able to let it alone though, and it was not exhibited until after his death, when it was still regarded as unfinished. Palmer told Valpy 'you have almost exactly described the scene in the description – your word picture – of a Hereford village', but in 1879 suggested it was a memory of Shoreham.[33] It is neither or both: an elegy for the passing not of a single day, but of a whole era.

By this stage, two years before his death in 1881, he was entirely used to inhabiting a world of multiple, simultaneous meanings, which could be presented, but not necessarily resolved. Palmer's last project, begun in 1872 and continued during his final decade alongside the Milton watercolours, was

60 *The Bellman*
1864–81
Watercolour and
bodycolour on card
50.6 × 70.5
(19⅞ × 27¾)
The Devonshire
Collection,
Chatsworth

61 *Opening the Fold*
or *Early Morning*
1880
Etching, forth state
11.7 × 17.5
(4⅝ × 6⅞)
Ashmolean
Museum, Oxford

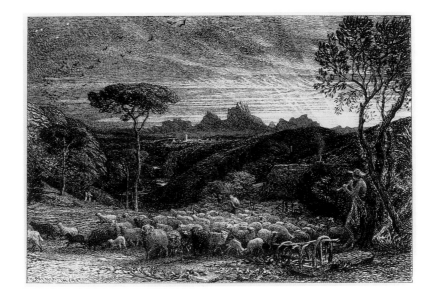

for a series of ten etchings to illustrate each of the *Eclogues* of Virgil. Palmer completed a free verse translation of the Latin poems in 1872, but was advised by P.G. Hamerton that it would be unwise to print them without illustrations. When finally published by A.H. Palmer in 1883, the work also comprised an introductory essay on the role of the pastoral in the modern age and extended notes which reveal Palmer's knowledge of the historical context and the long history of scholarly exegesis of the verses. Introduction, translation, notes and illustrations thus provide four levels of interpretation of the *Eclogues*. It is no coincidence that it was Blake's simple woodcuts made to illustrate a paraphrase of the same text that had triggered Palmer's most heartfelt early work. Returning to the source of his own art, he wanted now to counter Blake's naivety with all the verbal and visual sophistication that he could muster. The task he set himself was ultimately beyond him. Sketches for the ten designs were made and several plates begun, but only one of the ten etchings was completed: *Opening the Fold*, designed for Eclogue VIII (fig.61). The shepherd Damon, leaning, as Virgil describes him, 'against an olive's smooth trunk' is the 'piper at the gates of dawn'. Palmer elided the singing competition around which the text revolves with Damon's lament for his lost love; the image, similarly dense and compressed, unites an English thatched cottage with a distant view of the Roman Campagna. In the essay, though, this ostensibly idyllic sampling of idealised motifs is supplemented by an analysis of the pastoral which is more historically and socially aware. The text is the product of Palmer's continuing meditation not only on art and literature but also on the times through which he lived. In 1880, looking back over nearly fifty years of reform, Palmer confessed himself disillusioned with the political process. He cited the authority of John Stuart Mill that 'the blessing of liberty [depends] on the character of the free'.[34] It is against this background that Palmer seems to represent his shepherd Damon enjoying what Annabel Patterson has called the 'interior liberation that [he] read into Virgilian pastoral'. Even though the

visual form of commentary given in the etching appears at odds with the more nuanced reading of the introductory essay, Palmer at least has the honesty to let the tensions remain: 'self-contradiction becomes itself holistic'. Patterson concludes that 'Palmer's version of the "Eclogues" is a Victorian statement of anti-Victorianism, a counter-cultural document that offers pastoral as a cure for society's ills, but in which the diagnosis of the ills and the vision of the cure are formally and conceptually incompatible'.[35]

The only completed watercolour based on the *Eclogues*, *Tityrus Restored to his Patrimony* (fig.62), is superficially similar to the etching. Its lush sunset landscape expresses the shepherd's contentment at returning home after long exile (he is shown seated in a rich blue robe). Palmer knew, however, that the bliss Tityrus now enjoyed depended on the gift of the authorities in the city. And it is at their behest that Meliboeus, bearing his staff for the journey ahead, must now leave. Palmer's pastoral is not insulated from the urban world. It bears within it all the uncertainty and ambiguity of departure and return.

In conclusion, the overview of the critic Laurence Lerner seems particularly apt for Palmer, and his lifelong struggle to reconcile inner and outer worlds. Lerner called his study of pastoral poetry *The Uses of Nostalgia*, and suggested, among other approaches, a psychological interpretation of the pastoral as the recovery of lost childhood. Looking at the poignant meeting between the shepherds Tityrus and Meliboeus, two fragile lives disrupted by political events beyond their control, recalls Palmer's earliest memory of his nurse, Mary Ward. She first instilled his love of Milton, and Palmer attributed to her much of his future course as an artist. 'When less than four years old, as I was standing with her, watching shadows on the wall from the branches of an elm behind which the moon had risen, she transferred and fixed the fleeting image in my memory by repeating the couplet: Vain man, the vision of a moment made, Dream of a dream and shadow of a shade. I never forgot those shadows, and am often trying to paint them.'[36] In Palmer's art, the visions of a moment are everything and nothing. He spent his life attempting to capture shapes and forms he knew to be transitory. Doubly so, since the world he depicted was subject not only to change of light, time and season. For him, the visible world was no more than a foretaste of an ultimate reality yet to be revealed.

What he had glimpsed as a child, he did not abandon in later life. If Palmer interests us today, it is for the urgency of his belief, and the consistency with which he held on to it throughout a long and often unrewarding career. However captivating, his paintings, drawings and prints were for him only provisional, no more than that. Modern admirers of Palmer's work should be guided by one of the artist's favourite poets, the Anglican priest George Herbert, who in perhaps his most famous poem, 'The Elixir', published in 1633, wrote:

> A man that looks on glasse,
> On it may stay his eye;
> Or if he pleaseth, through it passe,
> And then the heav'n espie.

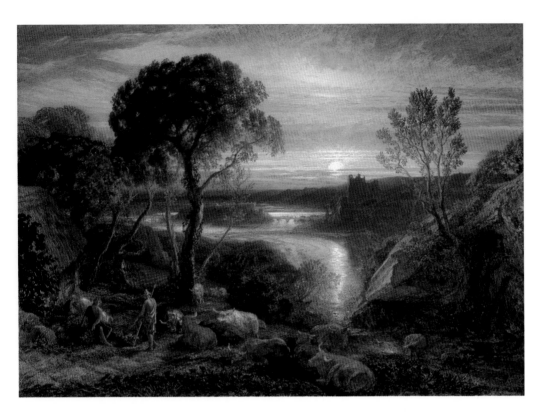

62 *Tityrus Restored to his Patrimony* exhibited 1877
Watercolour, bodycolour and gum arabic on paper
50.2 × 69.9 (19¾ × 27½)
Birmingham Museums and Art Gallery

Notes

Introduction
The Visions of the Soul

1 P. Wood *et al.*, *Modernism in Dispute: Art Since the Forties*, New Haven and London 1993, p.195.

2 T.J. Clarke, *Farewell to an Idea*, New Haven and London 1999, p.12.

3 A.H. Giles, *Aegidiana*, London 1910, p.141.

4 A.H. Palmer, *The Life and Letters of Samuel Palmer, Painter and Etcher*, London 1892, reprinted 1972, p.14.

5 Ibid., pp.15–16.

6 R. Lister (ed.), *The Letters of Samuel Palmer*, 2 vols., Oxford 1974, p.232 (hereafter referred to as *Letters*).

7 *Letters*, p.970.

8 M. Abley (ed.), 'Some observations on the country and on rural poetry' in *The Parting Light: Selected Writings of Samuel Palmer*, Manchester 1985, p.155.

Chapter One
Early Morning: Poetry and Sentiment

1 Palmer 1972, p.17.

2 From *A Vision of the Last Judgement*. See David V. Erdman (ed.), *The Complete Poetry and Prose of William Blake*, Berkeley and Los Angeles 1982, p.555.

3 Gerda S. Norvig, *Dark Figures in the Desired Country: Blake's Illustrations to 'The Pilgrim's Progress'*, Berkeley 1993, p.48.

4 M. Butlin, 'A New Portrait of William Blake', *Blake Studies*, vol.7, no.2, 1975, pp.101–3.

5 John Caspar Lavater, *Essays on Physiognomy*, transl. by Thomas Holcroft, 18th ed., London 1885, p.382. See also A.K. Mellor, 'Physiognomy, Phrenology and Blake's Visionary Heads' in R.N.

Essick and D. Pearce (eds.), *Blake in his Time*, Bloomington and London 1978, pp.53–74.

6 *Letters*, p.824; Palmer 1972, p.72.

7 It is assumed Palmer knew Shoreham before settling there in 1826. An early letter to Linnell, misdated 1824 by Palmer, must, from internal evidence, have been written in 1828. *Letters*, p.7; D. Linell, *Blake, Palmer, Linnell and Co: The Life of John Linnell*, Lewes 1994, p.120.

8 Palmer 1972, pp.13, 33, 37.

9 *Letters*, p.16.

10 *Letters*, p.36.

11 *John Linnell: A Centennial Exhibition*, exh. cat., Fitzwilliam Museum, Cambridge 1982, cat.1.

12 *Letters*, p.47.

13 J. Boys, *General View of the Agriculture of Kent*, 1805, cited in G.E. Mingay, 'Agriculture', in A. Armstrong (ed.), *The Economy of Kent 1640–1914*, Woodbridge 1995, p.69.

14 *Letters*, p.37.

15 Diary, 23 June 1829, MS, Fitzwilliam Museum, Cambridge. The painting was a repeat of a subject first painted on the Isle of Wight in 1816. The earlier version was sold, Christie's South Kensington, 20 July 1987, lot 122, repr.

16 Palmer 1972, p.16.

17 *Letters*, p.516.

18 E.J. Hobsbawm and G. Rudé, *Captain Swing*, London 1969, p.99. Love's son, another Samuel, also farmed at Shoreham, at Castle Farm, north of the village. The report does not specify whose property suffered, but it is likely to have been the father's, which bordered Otford parish.

19 M. White and J. Saynor, *Shoreham: A Village in Kent*, 1989, p.133.

20 D. Bindman, 'Samuel Palmer's "An Address to the Electors of West Kent", 1832, Rediscovered', *Blake: An Illustrated Quarterly*, Fall 1985, pp.56–9.

21 G. Grigson, 'Samuel Palmer: The Politics of an Artist', *Horizon*, vol.4, no.23, November 1941, p.321.

22 G. Barton and M. Tong, *Underriver: Samuel Palmer's Golden Valley*, Brasted Chart 1995, p.14.

23 A. Radcliffe, *The Mysteries of Udolpho*, vol.3, chapter 10, 1794; reprinted 2001, p.440.

24 *The Gleaner*, engraved by E. Finden after J. Holmes. *The Amulet*, 1830, opp. p.217.

25 D.H. Morgan, *Harvesters and Harvesting 1840–1900*, London 1982, p.161.

Chapter Two
Midday: The Pit of Modern Art

1 Palmer 1972, p.14.

2 *The Examiner*, no.742, 24 March 1822, p.186.

3 *John Bull*, vol.5, no.19, 8 May 1825, p.150.

4 *European Magazine*, new series, vol.1, no.1, September 1825, p.85.

5 *Letters*, pp.53–4.

6 *Athenaeum*, 19 January, 26 January and 3 February 1833.

7 *Literary Gazette*, 13 June 1829, p.394. Ibid., 9 June 1832, p.362.

8 *Athenaeum*, no.341, 10 May 1834.

9 *Letters*, pp.67, 65.

10 'Recent Acquisitions at the Fitzwilliam Museum', *Burlington Magazine*, vol.156, July 2004, p.511.

11 *Letters*, p.71.

12 *Letters*, p.304.

13 Erdman 1982, p.270.

14 *Letters*, p.672.

15 J.A. Froude, *Carlyle's Life in London*, 1884, vol.1, p.292, quoted in B. Willey, *Nineteenth-century Studies*, 1949, reprinted 1973, p.112.

16 *Letters*, p.152.

17 *Letters*, p.190.

18 *Letters*, p.163.

19 Ibid.

20 *Letters*, p.182.

21 *Letters*, pp.385, 386.

22 *Athenaeum*, no.291, 25 May 1833.

23 *Letters*, p.745.

Chapter Three
Sunset: Barbarians and Philistines

1 J.L. Roget, *A History of the 'Old Water-Colour' Society*, 1891, reprinted 1972, vol.2, p.272.

2 M. Hardie, 'Robert Hills: Extollager', *The Old Water-Colour Society's Club, Annual Volume*, vol.25, 1947, pp.38–40.

3 C. Payne, *Toil and Plenty: Images of the Agricultural Landscape in England, 1780–1890*, 1993, p.145, cat.55.

4 *Portfolio*, January 1878, p.7.

5 J. Linnell, Autobiography, Fitzwilliam Museum, Cambridge, MS 32–2000, f. 14.

6 J. Ruskin, *Works*, vol.3, ed. E.T. Cook and A. Wedderburn, 1903–12, p.604.

7 *Art Journal*, 1866, p.174.

8 Palmer 1972, p.103.

9 Payne 1993, p.57.

10 *Letters*, pp.465, 497.

11 G. Borrow, *Lavengro*, London, n.d., p.34. Borrow's fictionalised autobiography was the first sympathetic study of gypsy life as a distinct culture, but was published too late to have any great influence on the production, or reception, of Palmer's works on this theme.

12 T. Hilton, *John Ruskin: The Early Years*, New Haven and London 1985, p.101.

13 *Athenaeum*, no.1176, 11 May 1850.

14 *Letters*, p.680.

15 H. Beck, *Victorian Engravings*, exh. cat., Victoria and Albert Museum, London 1973, nos.29 and 31.

16 *Letters*, p.923.

17 *Letters*, p.775.

18 M. Arnold, *Culture and Anarchy: An Essay in Political and Social Criticism*, 1869, 1965 edition, Ann Arbor, p.95.

19 *Letters*, pp.536–7.

20 P.G. Hamerton, *Etching and Etchers*, London 1868, p.142.

21 MS letter, Fitzwilliam Museum, Cambridge.

22 E. Chambers, *An Indolent and Blundering Art? The Etching Revival and the Redefinition of Etching in England 1838–1892*, Aldershot 1999, Appendix 3, pp.195–201.

23 Palmer's later book illustrations were all in mixed anthologies. See R. Lister, 'The Book Illustrations of Samuel Palmer', *Book Collector*, Spring 1979, pp.67–103.

24 R. Lister, *Samuel Palmer and his Etchings*, London 1969, pl.33.

25 *Letters*, p.321.

26 J. Reynolds, *Discourses*, ed. R. Wark, 1959, new edition, New Haven and London 1975, p.238.

27 *Letters*, p.691.

28 *Letters*, p.743.

29 Ruskin, *Works*, vol.3, p.169 (see note 6).

30 *Letters*, p.137.

31 *Letters*, p.703.

32 *Letters*, p.695.

33 *Letters*, pp.699–700; p.970.

34 *Letters*, p.1013.

35 A. Patterson, *Pastoral and Ideology: Virgil to Valéry*, 1988, p.296.

36 *Letters*, p.823. The couplet is from Edward Young's 'Paraphrase of Job'.

Chronology

1805 Samuel Palmer born on 27 January in Newington, south London.

1817 Death of Palmer's mother.

1819 First paintings exhibited at the British Institution and the Royal Academy.

1822 Meets John Linnell.

1824 First visit to Shoreham. Meets William Blake.

1824/5? Formation of The Ancients.

1826 Buys property in Shoreham and settles there.

1827 Death of William Blake.

1831 'Captain Swing' agricultural riots in southern England.

1832 Palmer's 'Address to the Electors of West Kent'. Buys house at Grove Street, Lisson Grove, London.

1834 Summer tour to Devon.

1835 Summer tour to Wales. All but two small properties in Shoreham disposed of.

1836 Tour to Wales with Edward Calvert.

1837 Marries Hannah Linnell on 30 September at Marylebone Register Office. They travel through France to Italy with George Richmond.

1838–9 In Rome and Naples.

1839 They return to London in late November. Living in Grove Street.

1842 Birth of Thomas More Palmer.

1843 Associate Member of the Society of Painters in Water-Colours.

1844 Birth of a daughter, who dies in 1847.

1846 Illustrations to Charles Dickens's *Pictures in Italy*.

1848 First of several summer trips to Cornwall.

1850 Member of the Etching Club.

1851 Living at 6 Douro Place, Kensington.

1853 Birth of Alfred Herbert Palmer.

1854 Full Member of the Society of Painters in Water-Colours.

1861 Death of Thomas More Palmer.

1862 Moves to Furze Croft, Redhill.

1863 Begins work on Milton watercolours for A.R. Valpy.

1872 Begins work on etchings for edition of Virgil's *Eclogues*.

1881 Dies on 24 May.

Bibliography

Abley, Mark (ed.), *The Parting Light: Selected Writings of Samuel Palmer*, Manchester 1985.

Brown, David Blayney, *Samuel Palmer 1805–1881*, Loan Exhibition from the Ashmolean Museum, Oxford, London 1982.

Butlin, Martin, *Samuel Palmer's Sketch-book 1824* [facsimile]: *An Introduction and Commentary*, London 1962.

Carroll, Joseph, *The Cultural Theory of Matthew Arnold*, Berkeley 1982.

Catalogue of an Exhibition of Drawings, Etchings & Woodcuts by Samuel Palmer and other Disciples of William Blake, exh. cat., with introduction and notes by A.H. Palmer, Victoria & Albert Museum, London 1926.

Crouan, Katherine, *John Linnell: A Centennial Exhibition*, exh. cat., Fitzwilliam Museum, Cambridge 1982.

Gifford, Terry, *Pastoral*, London 1999.

Grigson, Geoffrey, *Samuel Palmer: The Visionary Years*, London 1947.

Harrison, Colin, *Samuel Palmer*, Ashmolean Handbooks, Oxford 1997.

Lister, Raymond, *Edward Calvert*, London 1962.

Lister, Raymond (ed.), *The Letters of Samuel Palmer*, 2 vols., Oxford 1974.

Lister, Raymond, *Samuel Palmer in Samuel Palmer Country*, East Bergholt 1980.

Lister, Raymond, *George Richmond: A Critical Biography*, London 1981.

Lister, Raymond, *Samuel Palmer and 'The Ancients'*, exh. cat., Fitzwilliam Museum, Cambridge 1984.

Lister, Raymond, *The Paintings of Samuel Palmer*, Cambridge 1985.

Lister, Raymond, *Catalogue Raisonné of the Works of Samuel Palmer*, Cambridge 1988.

Lister, Raymond, *The Life of Samuel Palmer*, Cambridge 1990.

Palmer, A.H., *The Life and Letters of Samuel Palmer, Painter and Etcher*, London 1892; reprinted London 1972.

Patterson, Annabel, *Pastoral and Ideology: Virgil to Valéry*, Oxford 1988.

Payne, Christiana, *Toil and Plenty: Images of the Agricultural Landscape in England, 1780–1890*, exh. cat., Yale Center for British Art, New Haven 1993.

Roget, John Lewis, *A History of the 'Old Water-Colour' Society*, 2 vols., London 1891, reprinted Woodbridge 1972.

Samuel Palmer: A Vision Recaptured: The Complete Etchings and Paintings for Milton and Virgil, exh. cat., Victoria & Albert Museum, London 1978.

Samuel Palmer: Visionary Printmaker, exh. cat. [by Paul Goldman], British Museum, London 1991.

Photographic Credits

Unless otherwise stated, photographic copyright is as given in the figure caption to each illustration.

The Bridgeman Library 1, 2, 20, 25, 34, 39, 41, 45, 48, 59

© 2005 Board of Trustees, National Gallery of Art, Washington, D.C. 7

Conway Library, Courtauld Institute of Art 10

© V&A Picture Library 11, 18, 27, 34, 47, 55

© 2005 Museum of Fine Arts, Boston 29

© Christies Images Ltd 2005 36

© 2004 Board of Trustees, National Gallery 51

Reproduced by permission of the Chatsworth Settlement Trustees 60

Index